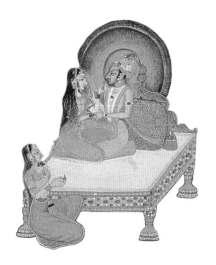

INDIAN

MINIATURE

PAINTING

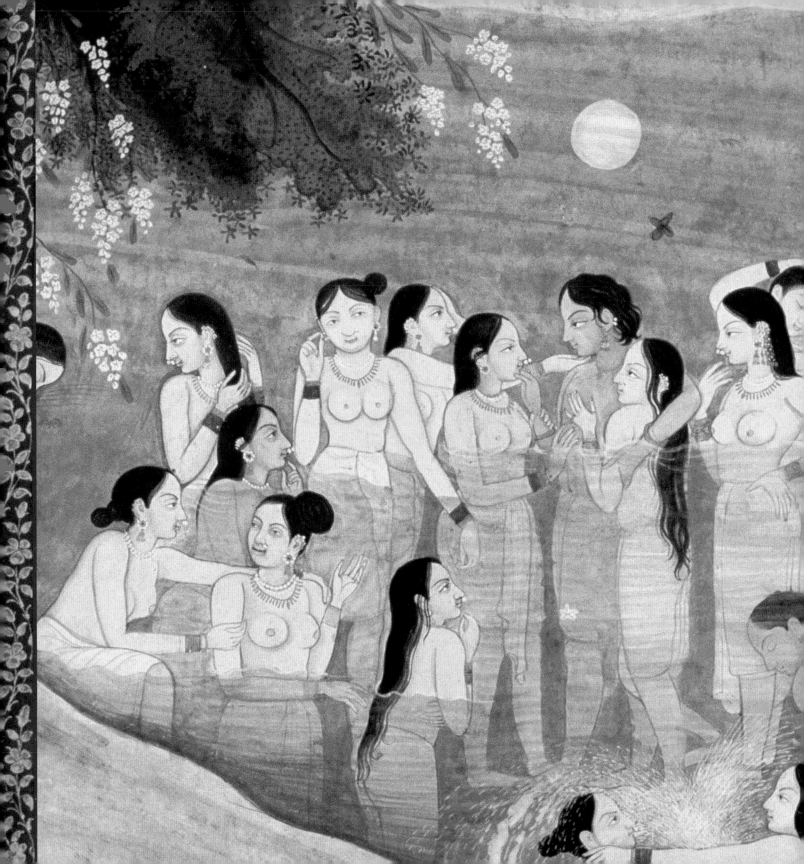

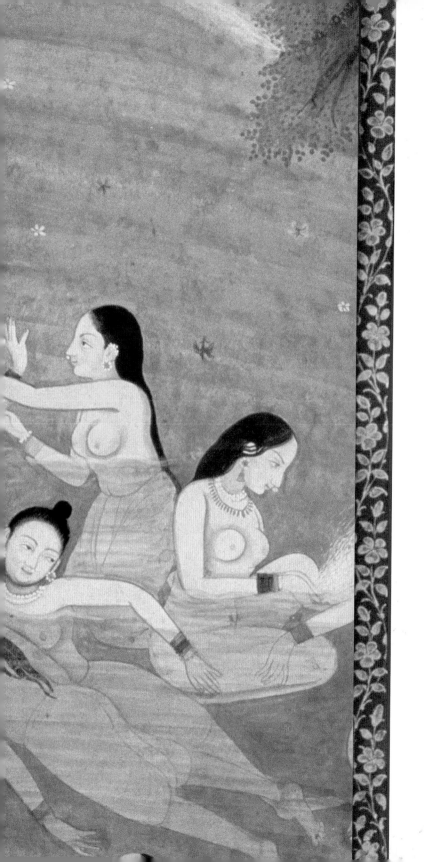

INDIAN MINIATURE PAINTING

ANJAN
CHAKRAVERTY

India Crest

Lustre Press
Roli Books

ACKNOWLEDGEMENTS

This book owes much to the help received from officials of various organizations, namely the British Library, the Victoria and Albert Museum, Musée Guimet, National Museum and Bharat Kala Bhavan, besides private collectors and scholars. I gratefully and gladly acknowledge their assistance. I wish to specially mention here the cooperation extended by
Dr Amina Okada, Dr Rosemary Crill, Ms Isobel Sendon, Ms P. Kattenhorn,
Prof M. A. Dhaky, Dr Daljeet, Dr K. Krishna, Dr T. K. Biswas,
Shri C. L. Bharani, Dr P. Pratap, Dr R. P. Singh, Shri S. S. Backliwala,
Shri Pramod Kapoor, Mrs Kiran Kapoor, Shri A. Kapoor and Dr N. Indictor.

PHOTOGRAPHIC CREDITS

Roli Collection (Dheeraj Paul, R.K. Duttagupta)
Royal Collection, Windsor Castle *(front cover, 32)*

Previous Pages: (Detail) *The Water Sport of Krishna and* Gopis, *Kangra, c. 1780-85, 35.1 x 27.7 cms. Bharat Kala Bhavan (No. 6700). See page p. 112-113.*

CONTENTS

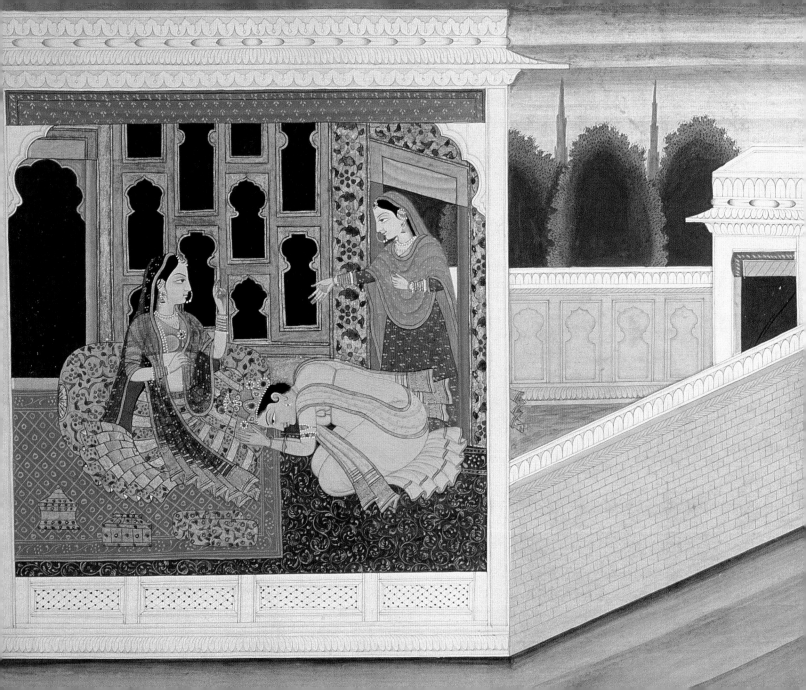

INTRODUCTION

This sweeping narrative centring on one of the vibrant expressions of Indian creative genius covers the time span between the sacred Buddhist palm-leaf manuscript illuminations of the 11th-13th century and the delightfully documentary 'Company paintings' produced essentially for European patrons during late 18th and 19th century. The process of development, remarkably uneven in its rhythm, was at times paradoxically coupled with the anonymity of most of its creators. Every era placed certain challenges before the painters who felt the need to assert their pride and reputation at least within the restricted circle of connoisseurs and clients. Every artistic innovation was observed, interpreted and critically evaluated in the guild; laden with meaning, painted imagery was expected to be functional in the context of a specific time and place yet represent a self-contained reality.

Historically speaking, both the tradition of Indian wall painting and miniature painting never flourished exclusively as an elitist activity. The folk and the courtly idioms were intermixed at various phases causing a bewildering variety of styles to emerge. Patronage was also not restricted to any specific religious order or social group. Each school unfolds a distinct norm of naturalism to which westerners are generally much unaccustomed to. In a language of symbols Indian miniaturists recorded their communion with nature, rich in wonder, awe and delight. Their minds excelled in expressing what lay beyond the primary function of lines and pigments, shifting emphasis from the multiplicity of sense—experiences to unifying ideas, from mutable aspects to an ever-present situation. Subjects derived from sacred myths or secular lores invariably served as the base for such a transformation of nature

into art and the spectator was transposed to a widely varying world of moods, from the sprightly to the introspective, from the romantic to the robust. In numerous such narrative-inspired paintings from Rajasthan and hill-states of Himachal Pradesh, the human form became a synoptic image and the background, a landscape of the mind. Conditioned by a different ethos, Mughal miniatures present situations or figural studies enriched with a pulsating finish and closely resembling their real life prototype. Intentionally or inadvertently, they were meant to evoke an imperial image in all its splendour and majesty. Extraneous impact may be classified under two broad headings, namely Persian and European. The Turkman Shirazi conventions influenced the pre-Mughal painting. Similarly, Safavid art ideals were the bedrock of early Mughal, and some of the motifs continued side by side with the Flemish-derived laws of spatial recession and modelling. And finally, during the British period native painters adopted transparent watercolour technique as also the basics of naturalistic portrayal, at times at the cost of subtle symbolic nuances.

As early as 1619 Mughal images reached London and between 1654-56 they were copied in Amsterdam by Rembrandt, who was enchanted with the delicate details of garments and jewellery. Indian miniature painting is 'visual chamber music' to be savoured slowly,

intently and rather privately. The word miniature derives from the Latin *minium* (red lead) which was used to emphasize the initial letters in a manuscript by a *miniator*. Inspite of a mistaken etymology since the 17th century, the word 'miniature' was connected with 'minute' and was also used to describe small portraits of the Elizabethan era painted on vellum, ivory or card and worn as ornaments. In the Indian context, 'miniature' generally refers to a painting or illumination, small in size, meticulous in detailing. The art of palm-leaf illumination was traditionally labelled as *patra-lekhana* in medieval Indian canons. But later, a generalized term *pata-chitra* was conventionally used to define paintings other than wall painting. It included painted scrolls and panels. Modern museums display miniatures so that they can be viewed at a time by several spectators. Traditionally, painted folios were either bound along a spine like Islamic books or were piled carefully, wrapped in cloth and tied in bundles. A connoisseur, eager to enjoy the painted subtleties held the folios, one at a time, on the lap or on a table. Rarely were they framed and put behind glass or displayed on walls.

This survey does not take up the delicate problems of provenance and dating or present all the current research on the subject. It is meant to be an *apéritif* for those who wish to enter the world of Indian miniatures and experience its painted delights. Scholars in the field have

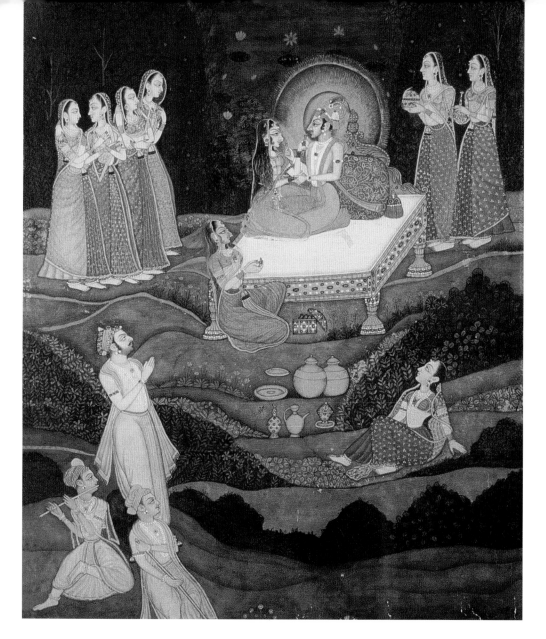

painstakingly traced the path of the development of each genre and generously shared their insights about every hidden nuance. Throughout, I have based my interpretations on their works and drawn immensely from their critical views. But this would have merely been a mechanical task had I not been familiarized with the basic language of form and colour in the gallery of Indian Miniature Painting at Bharat Kala Bhavan, Varanasi by my parents when I was only ten. Those magic moments will forever remain timeless for me.

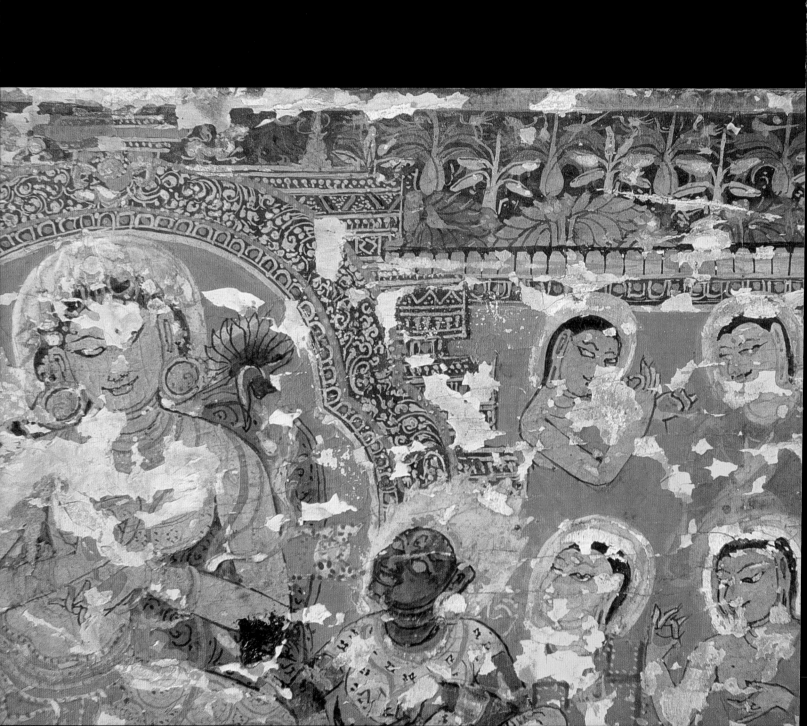

THE TRADITION OF MANUSCRIPT ILLUMINATION: EASTERN INDIA

A major school of manuscript illumination flourished in the Buddhist monasteries of eastern India, Bangladesh and Nepal during the reign of the Palas (c. A.D. 800-1200), who were ardent followers of *Mahayana* Buddhism. A later development, *Vajrayana* Buddhism stressed on meditation and worship of Cosmic Buddhas, *Bodhisattvas* and a host of divinities. Images of the divinities were therefore realized in stone, metal and in wall paintings, banners and manuscript illuminations, according to strict and detailed iconographic rules. Depictions of Buddhist deities, the major events of the life of Buddha and occasionally, narrative sequences from the *Jatakas*, became an inseparable part of the art of the religious book. The manuscripts, with calligraphy of austere grandeur and superbly painted iconographic details, became primarily objects of veneration, being more worshipped than read.

A collection of *tadapatras* or slender, rectangular, talipot palm leaves, strung together with cord and held between two wooden binding boards, constituted the basic format of a Pala manuscript. The text was carefully inscribed in the *kutila* (crooked) script and on certain folios, oblong spaces (5.5 x 7.5 cm.) were left for the painter. The inner side of the wooden covers were embellished with the paintings of Cosmic Buddhas, *Bodhisattvas* and numerous protective deities. The exteriors, embellished with floral patterns, were invariably obscured by repeated ritual daubings of sandalwood paste, vermilion, oil and milk.

Commissioning, as well as transcription of the religious texts and their donation to the great Buddhist libraries was believed to bring merit to the patron and to the scribe (*lekhaka*). Ironically, not a single manuscript bears the name of the painter, though colophons record the

name of the donor, the scribe, the place and year of execution.

Numerous Buddhist texts were copied and illustrated in the monastic scriptoria as well as in the professional ateliers to cater to the needs of the monastic-cum-educational establishments of Nalanda, Kurkihar, Vikramshila, Uddantapuri and Sri Halm. The *Ashtasahasrika Prajnaparamita* (Perfection of Wisdom in Eight Thousand Verses), the *Pancharaksha* (Five Protective Charms) and the *Dharanisamgraha* (Collection of Charms) appear to be the most favoured texts for illustration. None of them, however, offered the painter a narrative core appropriate for illustration.

The use of flowing lines and colour, applied in a blended sequence, to raise up the plasticity of the figures marked the works of the early and mid-11th century. By the beginning of the 12th century, this technique was replaced by quickly applied crisp, angular patches and the lines displayed 'a nervous energy.' The pigments were made from minerals and organic sources and tempered with glue, a similar process to that used in the wall paintings

of Ajanta. The palette consisted of white (burnt conch shell), yellow (orpiment), blue (lapis lazuli), vermilion (cinnabar), crimson (lac-dye), Indian red (red ochre), green (terra-verde) and black (lamp black). The palm leaves were cut into a fixed size and burnished with a stone to make the surface smooth. The final sketch *(rekha-karma)* was drawn with red ochre on a thin coat of white priming. Different parts of the composition were filled with colours *(varnakarma),* which were then softened with repeated application of transparent, darker tones *(vartanakarma)* to produce an effect of roundness and volume. Every detail was then strengthened carefully with a thin brush. The wooden covers were also painted in the same manner but were given a final protective coat of resinous varnish.

Many monastic libraries were destroyed by the Turkish invaders, Muhammad of Ghur and Bakhtiyar Khalji, who swept across the plains of northern and eastern India after A.D. 1192. Their ruthless iconoclasm compelled the Buddhist monks and painters to flee to the Himalayan region and Nepal in search of security and congenial conditions.

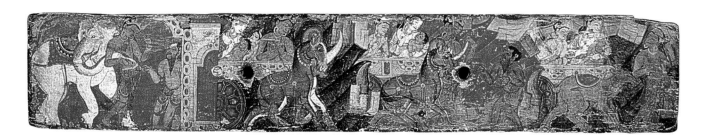

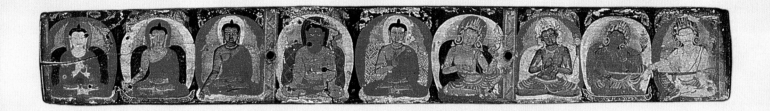

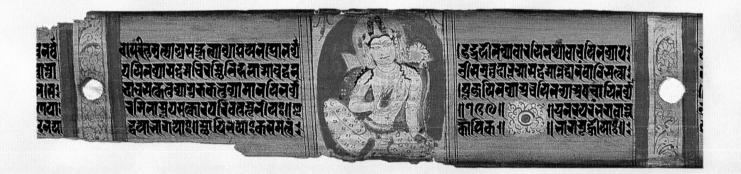

Above

Five Cosmic Buddhas and four Vajrayana *deities. Pala, c. 1100; opaque watercolour on wooden board, varnished; 55.3 x 7.5 cms. Bharat Kala Bhavan (No. 4794). This is one of the two painted, binding boards to match the illustrations of the Ashtasahasrika manuscript belonging to the fourth regnal year of a certain Gomindrapala. The five Cosmic Buddhas play a crucial role in the Vajrayana pantheon and their presence is to ensure protection to 'the devotee of the perfection of wisdom.'*

Below

Vessantara Jataka. *Pala style in Nepal, c. 1100; opaque watercolour on wooden board; 32.8 x 5.7 cms. National Museum (No. 51.212). Depiction of scenes from a narrative, utilizing the entire space provided is rare among the surviving examples of Pala painting. Here an integrated composition depicts several episodes from the* Vessantara Jataka *story. The narrative fluidly passes from one phase to the next, punctuated into separate segments by the clusters of sumptuously painted prismatic rocks. The three situations are: Vessantara, an incarnation of Bodhisattva and a believer in the virtue of charity, giving away his elephant (left), going into exile with his family (centre) and finally giving away his royal chariot (right).*

THE TRADITION OF MANUSCRIPT
ILLUMINATION: WESTERN INDIA

The western Indian tradition of manuscript painting spread over the Gujarat and Rajasthan area. It evolved steadily from the 11th to the 16th centuries, despite iconoclastic depredations caused by the Muslim invaders. Contributing significantly to the development of the Rajasthani School, it also shaped the vocabulary of visual expression of Indian miniature painting at a formative stage. The regional manifestations of this style at Mandu, Gwalior, Delhi and Jaunpur, were equally important in this respect.

Veneration of the scriptures *(jnana-puja* or *sastra-puja)* was an age-old practice among the Jainas. Temple libraries *(jnana-bhandaras* or *sastra bhandaras),* established by 8th century A.D., were headed by erudite monks called *bhattaraks.* They zealously acquired and commissioned manuscripts, mainly of religious texts and occasionally of works on grammar, rhetoric and astrology. It was they who encouraged bankers and merchants as well as the laity to donate transcriptions of sacred texts to the *bhandaras.* This act of *sastra-dana* came to be considered as virtuous. The *sastra bhandaras* of Patan, Cambay, Jaisalmer and Abu became veritable grand repositories of palm-leaf and paper manuscripts, painted scrolls *(patas)* and numerous other documents related to art and literature. Numerous such *bhandaras* are credited to the two Solanki kings of Gujarat, Siddharaja Jayasimha (A.D. 1093-1143) and Kumarapala (A.D. 1143-72). Both were known for their lavish patronage to several hundred scribes who copied some of the text in golden ink.

The canonical texts of Jainism, 'rich in their metaphysical profundity' were suitably counterpoised by non-canonical literature comprising psalms, legends, fables and biographies of *tirthankaras* (the omniscient spiritual

Facing Page

Twenty tirthankaras *in contemplation. Western Indian,* Kalpasutra *A.D. 1459; folio: 27 x 11 cms. National Museum (No. 63.591:85r).*

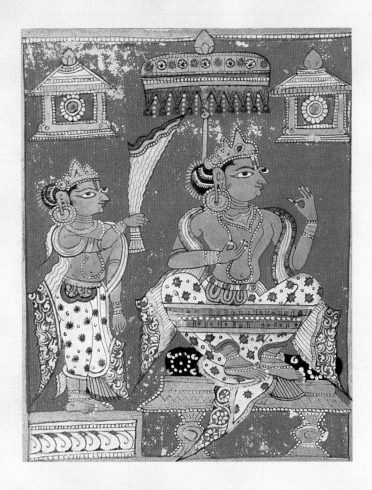

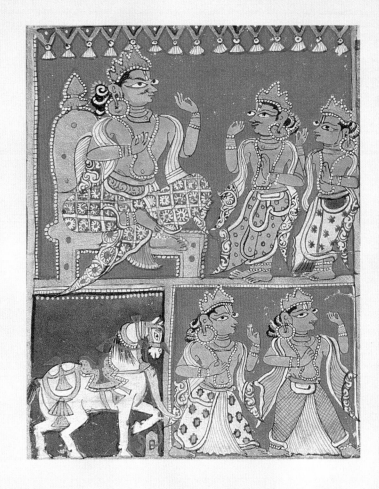

Indra with an attendant. Western Indian; Mandu. Kalpasutra Ms. A.D. 1439; folio: 24.4 x 10.3 cms. National Museum (No. 49.175:5r).

King Siddhartha ordering messengers to bring soothsayers, Mandu Kalpasutra Ms, A.D. 1439, folio: 24.8 x 10.9 cms. National Museum (No. 49.175:20r).

teachers) and *kathanakas* (little tales). The *Kalpasutra* (The Book of Sacred Precepts), with its two important hagiographic sections on the founders of Jainism is undoubtedly one of the most revered texts of the *Svetambaras* and was often selected for making illustrated copies to be offered. Other narrative works taken up for illustration were the *Kalakacharyakatha, Adi Purana, Maha Purana* and *Yashodhara Charita.*

The earliest Jaina manuscripts of the 11th and 12th centuries, very much like their Buddhist counterparts from eastern India, consisted of loose palm-leaves threaded with a cord, passed through string-holes and secured between a pair of painted wooden covers *(patlis)*. A splendid textile wrapping protected the manuscript. The paintings were in no way related to the accompanying text and as a rule, they appeared only on the

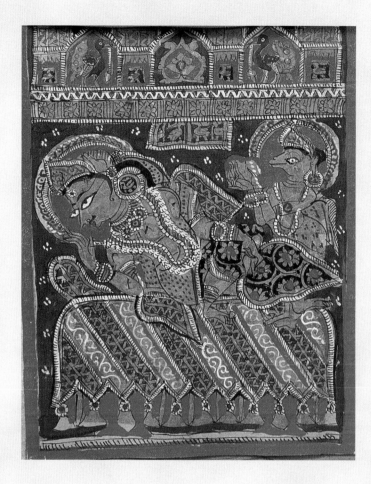

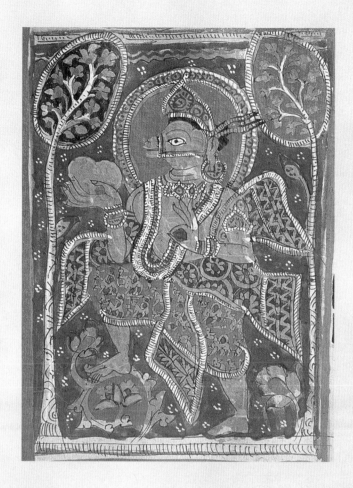

introductory and concluding folios, to augment the esoteric dimensions of the manuscript. Painted normally with narratives, icons and flowing creeper patterns, the *patlis* exhibit a freedom in style.

Paper was introduced in the 14th century as a formidable alternative to palm-leaf for manuscripts. A modification of the palette followed, with a marked stress on ultramarine (lapis lazuli), crimson, gold and silver. These two factors were significant in the development of Jaina and non-Jaina painting during the 14th and 15th centuries. The paper manuscripts were oblong like the palm-leaf folio except for a larger size. The wooden covers were no longer elaborately painted and the binding string was also discarded. The string-holes were superficially demarcated with red or gold circles to enhance the rhythm of calligraphy in black ink.

Transference of the Embryo. Western Indian, Kalpasutra, Ms. A.D. 1459, folio: 27 x 11 cms. National Museum (No. 63.591:19r).

Yaksha Harinaigamesha carrying the Embryo. Western Indian, Kalpasutra Ms. A.D. 1459; folio 27 x 11 cms. National Museum (No. 63.591):17v).

Indra with gods in heaven. Mandu Kalpasutra *Ms. A.D. 1439; folio 24.5 x 10.3 cms. National Museum (No. 49.175:10r). The style of this illustrated manuscript* (kalapustaka) *is less geometric; lines are smooth and the pigments brushed with care. Gold in a liquified form is used for transcribing the text as well as to heighten jewellery and furniture. Seated on a golden throne, Indra, the chief of the gods, converses with a group of four gods placed in two rows. The ends of the sash decorated with floral meanderings in crimson were directly inspired by the contemporary printed calico of Gujarat.*

The overriding influence of the Muslim power in Gujarat at the end of the 13th century was mirrored in the decades of uncertain religious toleration that curbed the building activity of the pious and affluent Jainas. They instead chose to divert their piety and legendary wealth towards commissioning copies of sacred literature which were executed secretly and were often stored in underground chambers to escape destruction. Amidst the circle of elites and nobles during the reign of sultans in Gujarat there were keen bibliophiles. Some of the contemporary local illustrators of the Jaina and non-Jaina texts who were able to access such collections had a chance to observe various fascinating peculiarities of the art of these Islamic books.

Roughly between A.D. 1350 and 1550,

a certain diversification in style may be detected. By the mid-15th century, the Gujarat and Rajasthan palette became a little stereotyped, being dominated by gold leaf, lapis lazuli and transparent carmine. The illustrators improvised a new method of covering the area to be painted. They used thin gold foil and then proceeded to outline the contours in black, followed up by the application of various other hues. A remarkable portion of the gold base that was left unpainted dazzled in between the opaque and transparent coats of pigment. The art historians have rightly labelled this idiom as the 'opulent style.' As opposed to this striking feature, the drawing steadily lost its earlier tautness. The painters crammed the borders with a profusion of

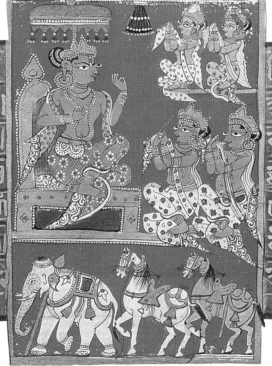

vivaciously stylized human, animal, and bird forms set against synoptic landscape or sprawling arabesque. The calligraphy was often done in gold or silver ink on vermilion, crimson or blue base tints. In contrast the pictorial effect of the illustrated manuscripts from Delhi, Gwalior, Mandu and Jaunpur was marked by less redundancy in detail and a more saturated colour scheme.

The painter's name was never included in any of the colophons of the illustrated manuscripts. The scribe was possibly the master visualizer who first marked the spaces *(alekhya sthana)* with brief captions or with a thumb-nail sketch for the painter. Iconic and symbolic interpretation of the early palm-leaf manuscripts were absorbed gradually into a style that moved towards a palpably narrative expression. The enlarged format of the paper manuscripts prompted the painters to conceive of elaborate compositions with stylized figures placed against flat monochrome grounds of warm red or intense blue. Ornamental pictograms depicting trees, rivers, mountains and cloud patterns conjured up landscapes of the mind besides referring to certain stories from the legends. The austere geometric schematization of the figural forms were in contrast to the sensuous plasticity of Buddhist palm-leaf illuminations. Faces were drawn in profile or in three-quarter profile with a long nose and a pointedly oval further eye protruding

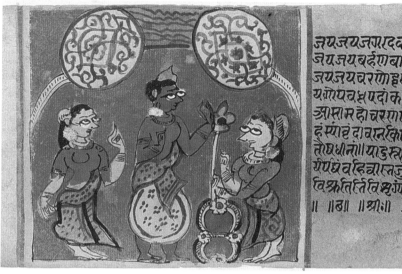

over the cheek. This mannerism was borrowed from the 9th century wall paintings of Ellora.

As against several thousand illustrated Jaina manuscripts, only a handful of non-Jaina ones survived. The scroll of the *Vasanta Vilasa* (The Sport of Spring) and the contemporary illustrated copies of *Balagopala Stuti* (Eulogy of the Child Cowherd) from Gujarat, offer fluid figural representations and a renewed interpretation of the pictograms for the trees, hills, lily-ponds and skyline. Such alterations were consciously programmed to suit the non-hieratic nature of these works.

Vasant Vilasa is loaded with graphic expressions of the spring mood and in all the vertically unfolding 79 panels, painted in tempera on primed cotton is apparent.

Krishna with milkmaids. Western Indian, Balagopalastuti Ms., c. 1480; folio: 23:3 x 10.7 cms. Bharat Kala Bhavan (No.; 7400:32). Hastily outlined figures demonstrate the lack of skill and a loosening of the compact compositional structures of the illustrated Jaina Kalpasutra. Programming of each narrative episode is inspired by the Krishna legend beyond the immediate thematic baseline of this hymnal text. A pair of medallion-like tree forms jutting in from the either side have, instead of leafy patterns, scrolling arabesques derived directly from the contemporary Islamic bookbinding.

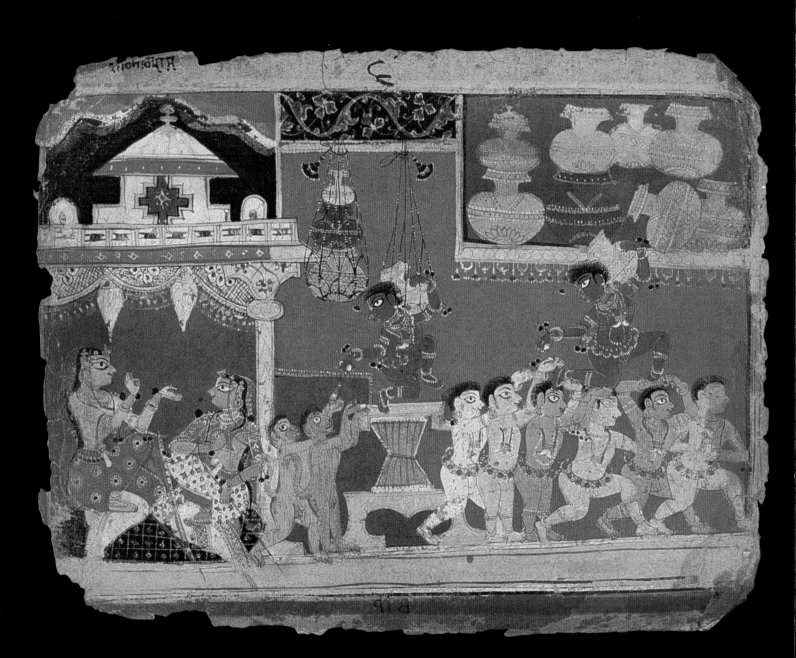

THE PRE-MUGHAL TRENDS

The styles of miniature painting that flourished in the pre-Mughal courts of the Muslim Sultanates and under the aegis of art loving bourgeois have a rather precarious chronology. The period was characterized by intense religious fervour expressed in passionate devotionalism. It witnessed the intermingling of two cultural sensibilities, the indigenous and the Islamic which was reflected vividly not only in painting but in architecture, music and literature. Following the existing norms of manuscript illumination, the painters' techniques, sources of inspiration and levels of talent were disparate. Although short-lived, these styles played an important role in the emergence of the Mughal idiom in Akbar's imperial atelier. Most of the themes taken up for visual elaboration were derived from legends. 'Artistic individuality' and 'the painter's responsiveness to an individual patron's demand,' the two key factors in the growth of Mughal painting, were of little importance at this stage.

Absence of sufficient dated material marks the history of painting during the rule of Mamluk Sultans (A.D. 1192-1298), the Khiljis (A.D. 1290-1320), the Tughlaqs (A.D. 1320-1414), and the Sayyids (A.D. 1414-51) in northern India. Nevertheless, delightful details are provided by the sporadic references to painting in the literary works of the Sultanate era. Masud Bak, a mystical poet of Feroz Shah Tughlaq's reign (A.D. 1351-88), compared the Creator to a maker of painted images:

The designer (*naqqash*) who without
 instruments made a picture (*tasvir*),
See that the painter (*musavvir*) is not separate
 from the image (*surat*);
If the eye of contemplation should be opened
In the depth of each picture (*naqsh*) you
 will behold what thing it is.

(*Chandayana*, tr. S. Digby, 1967)

Facing Page

Krishna, the butter thief.
Bhagavata Purana *Ms.,*
c. 1550; 23.5 x 18 cms.
Bharat Kala Bhavan
(No. 10663). The
Bhagavata Purana *(c.*
8-10th century) remained
an exhaustive source of
legendary material put
together to glorify all the
incarnations of Vishnu
and to recount the deed of
Krishna, the Blue God.
Inspired by the text, the
artist depicted the divine
child stealing butter kept
out of his reach with the
help of his companions
and giving even to the
monkeys their share of
the spoils.

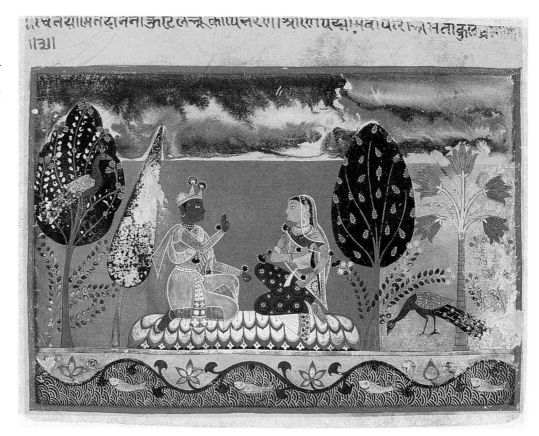

Feroz Shah, whose fanaticism and religious bigotry was legendary, banned wall decorations with animate subjects.

Several contemporary Hindi poems repeatedly refer to a Hindu tradition of figurative wall painting that survived in northern India. Poet Mulla Daud's *Laur-Chanda* or *Chandayana* (The Story of Chanda), gives an exquisite description of wall decoration in gold on a vermilion background:

The Pavilion was garnished with red decoration,
and the pictures and painting made golden;
a picture of Lanka and the flight of Vibhishan,
and the body of Ravana, as if real;
the seizing of Sita, the battling of Rama, Duryodhana and the Pandavas at the place of Kurukshetra;
The black thief and the white gambler;
Agiya the vampire in Ujjain city...
Various kinds of lions (*simha*) and *sardulas*, and deer (*mriga*) in the animal forest;

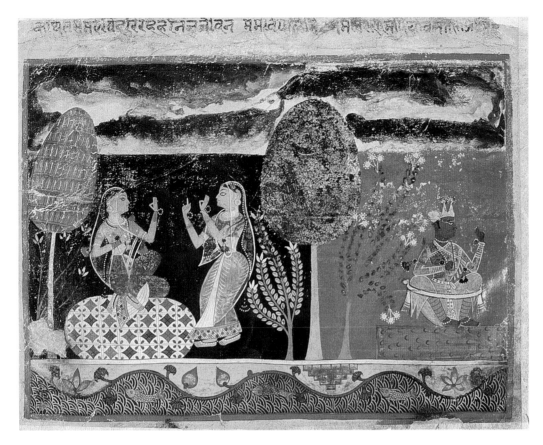

राधान मध्दवटतररहझमनीवन ममादप्र मभरूख ल य फन

Krishna pines for Radha in the grove while Radha speaks to her confidante: 'Just when we promised to meet, Hari avoided the woods. The flawless beauty of my youth is barren now. Whom can I seek here?' Pre-Mughal, Gitagovinda *Ms., c. 1570; 24.5 x 18 cms. National Museum (No. 56.146:1).*

A twilit other world of tales and poems, inscribed in a long line there.

(*Chandayana*, tr. S. Digby, 1967, Stanza 205)

The close of the Tughlaq regime saw the establishment of independent provincial kingdoms at Gujarat, Malva and Jaunpur. Itinirent painters from Persia were attracted to these centres of culture. Illustrated, as well as unillustrated Persian manuscripts, usually of the Bukhara and Shiraz style, made their way into royal libraries. A cultural renaissance took place under the Lodis, (1451-1526), some of whom had a literary leaning. Though they never patronized painting, a good number of illustrated and dated manuscripts covering Islamic and Hindu themes have surfaced. The Islamic manuscripts are marked by a lyrical and idealized style, whereas the Hindu manuscripts are full of vigour and sensuous charm.

Bhakti, or passionate devotionalism, hastened the transformation of the existing forms of religious, cultural,

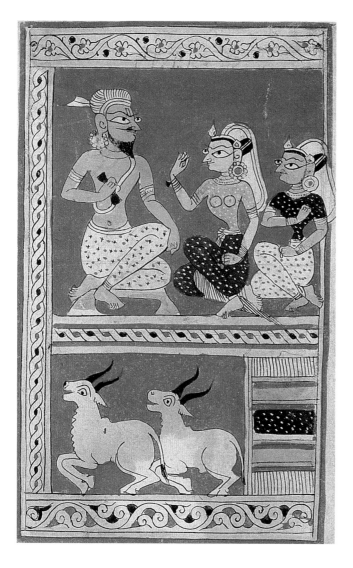

Maina, talking with the caravan master. Pre-Mughal, Laur-chanda *Ms. c. 1450; 18.5 x 11.6 cms. Bharat Kala Bhavan (No. 230).*

role of Sufi poets, who introduced nuances of the Perso-Arabic literary tradition into the vernaculars. Along with Sanskrit texts, these literary works in vernacular languages motivated the painters. Love, human or divine, continued as the dominant theme, suitably couched in narrative situations.

The stylistic variations of pre-Mughal painting can be best appreciated by sorting them out in distinct groups. The loosening of the hieratic Jaina style to cope with the requirements of non-Jaina themes, namely the captivating romances in Avadhi or the legends of the Islamic world, may be noticed in one group of manuscripts. The two illustrated series of *Laur Chanda* are outstanding representations of this style. Dating back to c. 1450-70, they possibly came from the Delhi-Jaunpur belt. The poem expresses the eternally enduring relation between 'the mystic and his divine Beloved' in the language of human love, which is typical of Sufi mystical insight. The division of the vertical format of the folios in registers, the highly suggestive simplification of human and animal forms and the use of swift, wiry lines to demarcate angular features are some of the salient aspects of this style. Ultramarine, vermilion, yellow ochre and white create a brilliant effect enhanced by the black outline.

The manuscripts produced between 1490-1510 at Mandu in central India belong to a separate group. *Nimatnama*

literary and aesthetic expression of this era. Vernacular languages absorbed the classical influences and drew from Sanskrit literature. *Avadhi* and *Brajabhasa*, the two major constituents of Hindi, were employed for the enormous body of Vaishnava literature. Relevant here is the

(Book of Delicacies), *Miftah-al-Fuzala* (A Glossary of Rare Words) and Sadi's *Bustan* (The Orchard) are outstanding illustrated manuscripts done in the Turkman style of Shiraz and Herat. All the fifty miniatures of the *Nimatnama* document various shades of epicurean delight. They were commissioned by Ghiyath-al-Din Khilji of Malva, (who ruled from 1469 to 1500) and by his son Nasir-ad-Din Khilji during his eleven year reign (1500-11). Chinese foliated clouds, rounded hillocks, sumptuously painted tapestry of foliage and well-constructed tanks with lotuses and birds create the ideal background for leisurely activities engaging the ruler. He is the only man to be portrayed in the entire manuscript. The others are large-eyed ladies of the seraglio, wearing Persian gowns and turbans, or dressed up in richly patterned *ghaghras* (skirts) and transparent *odhanis* (wimples). Art historians are of the opinion that an itinerent Persian painter was assisted by an Indian apprentice, eager to imitate his master's studied refinement of the Herat school. The immediate aftermath of this process of Indo-Islamic assimilation is best exemplified in a pair of illustrated *Laur Chanda* which have been claimed by the critics as the product of 'a sophisticated Muslim court, whose artists had at some previous stage, been exposed

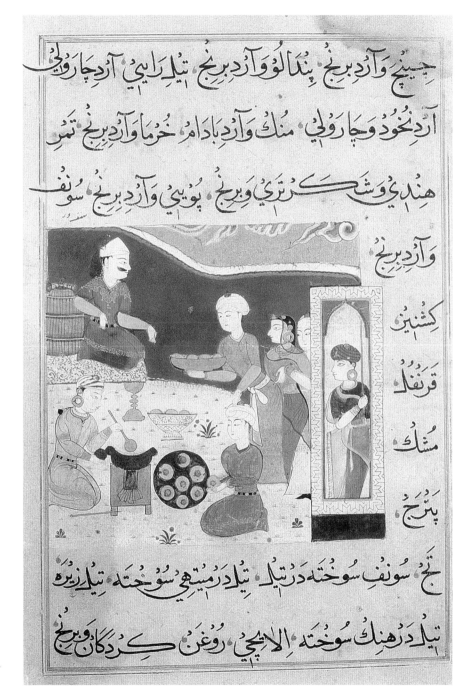

Sultan of Mandu directing the preparation of sweets. Pre-Mughal, Nimatnama *Ms., c. 1490-1510; 31 x 21.5 cms. British Library, (Persian Ms. 149, f. 836).*

Krishna attacking demon Vyomasura. Pre-Mughal, Bhagavata Purana *Ms., c. 1550; 22.7 x 17.7 cms. National Museum (No. 63.1598). This earliest illustrated* Bhagavata *manuscript with Sanskrit text on the verso has an entire series of brilliantly inventive and energetic portrayals of the myth. The idea of separating the picture and the text was preferred for richer pictorial effect. The painters belonging to this tradition of book production were recruited to work in Akbar's royal atelier. Krishna's life was constantly threatened by the wicked king Kansa who sent many demons in disguise to kill him. Demon Vyomasura, adept in conjuring tricks, carried away cowherd boys and imprisoned them in a rocky cave. Catching hold of the demon by his arm, Krishna killed him. Organized into compartments filled with basic colours of even intensity, the composition has a markedly diagonal stress. The episodic succession of the story was suggested with simultaneity of action.*

to considerable Shiraz influence' but, 'had long passed the stage of imitation.'

Finally, a number of illustrated manuscripts of Sanskrit devotional literature, Avadhi romances and of the *Ragamala* texts (Garland of Musical Modes) form a fascinating group popularly referred to as the *'Chaurapanchashika* group.' The dynamic brushwork and the vigorous symbolism of this idiom found widespread expression, with subtle regional variations in the 16th century. It was centred mainly in the Delhi-Jaunpur belt, but possibly extended to other regions, viz. Rajasthan, Malva and the Punjab hills. The earliest dated manuscripts, is *Aranyaka Parva* (The Forest Book, the third section of the *Mahabharata*) of A.D. 1516, painted at Kachhauva (Agra) during the reign of Sikandar Shah Lodi. The last, a startling discovery, is a copy of *Devi Mahatmya* (the Glorification of the Great Goddess) completed in A.D. 1552 at Jayasingh Dev Nagar (Kangra). Thus, a style aimed at clarity of narration and vivid visual effects persisted side by side with the experiments of the royal workshop of Akbar. Lines of uniform thickness, having a steely strength, became

the quintessential means of articulation. Scale relationships between the human figures and the landscape were invariably disregarded. For the sake of clarity, the full page compositions were invariably divided into registers, each one representing a portion of the episode. Architecture with distinctly defined parts look like painted cutouts. An exciting wealth of possibilities in colour dynamics was fully realized by the painters who introduced blazing red backgrounds to highlight certain segments of the narrative. Fine detailing of the creeper-entwined trees evoke the mood of an everlasting spring. The female figures with 'flamboyantly curvaceous' torsos display a tautness, characteristic of the Jaina idiom. They wear tight blouses, patterned skirts and diaphanous *odhanis* with ends standing out at sharp angles. The male figures are either dressed in *dhotis* and *uttariyas* (graceful scarves) or in *chakdar jamas* (tunics with four or six pointed ends) tightly held around the waist with a *patka* (sash). The Afghan skull-cap tied with a turban is another predominant male sartorial feature. The faces are all standardized profiles with prominent wide-open eyes. Emotions are conveyed through the movement of limbs and lively hand gestures. The undated *Bhagavata Purana*, a key manuscript of the group, comprises compositions where events separated in space and time are included simultaneously. The *Mrigavat* series illustrates 'a strange tale of love, fantasy,

magic and the supernatural.' It follows the known formulae of the *Chaurapanchashika* blended with a folk vigour. The two illustrated copies of poet Jayadeva's *Gitagovinda* (The Song of the Cowherd God) suitably evoke the pastoral backdrop of Vrindavana, with lotus-laden river Yamuna, flowering bowers, stately plantains and brightly plumed peacocks. Every such motif amplifies the poetic metaphor and bring out the inner symbolism of the text. Saturated hues and breaking of the horizontal space into units are the two dominant conventions of the style.

Prince Biraspat as a yogi in search of Princess Mrigavat. Pre-Mughal, c. 1560; 18.3 x 17.2 cms. Bharat Kala Bhavan (No. 7868).

Master Painters Master Strokes

~

The Indian miniaturists used the deceptively simple technique of opaque watercolour. Except for the earliest Buddhist and Jaina manuscript illuminations done on palm leaf and the incidental use of mounted cotton cloth in the Mughal and Rajasthani ateliers, paper was the most popular and also the most readily available medium. Major kinds of handmade paper made available to the Mughal painters were: *Daultabadi Nizamshahi* and *Adil Shahi* from Deccan, *Khatai* from north China and *Gauni, Isfahani* and *Sultani* imported from Persia. Some of the major paper-producing centres of Mughal India were Sialkot, Kashmir, Kalpi, Ahmedabad, Daultabad, Junnar and Sanganer.

Two or three thin sheets of paper were fused together with book-binder's paste to form a paste-board (*vasli*) strong enough to be painted. In the Mughal atelier these paste-boards were fabricated by a special class of artisans known as *vasligar*. The painter would first sketch out the initial structure of the composition or the basic outlines of the portrait with a watery tint (*abrang*). Sitting on the ground, he would rest the *vasli* on his raised knee. Sometimes the initial drawing was done on a different paper and then transferred on to the *vasli* by perforating the lines with a needle and pouncing them with powdered charcoal. Once the rough contours of a drawing were established, or the drawing transferred from the pounces *(charba)* was

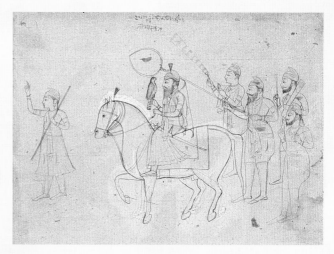

Guru Gobind Singh, the last Sikh Guru on march. c. 1820; 19.8 x 14.5 cms. S.S. Backliwala Collection. The drawing shows the altered contour of the horse, scumbled in white, hiding the correction.

secured by the brush, it was given a thin coat (*astar*) of white lead treated with gum arabic medium. With the help of rough outlines visible through the white scumbling, the painters succeeded in recovering the entire drawing with almost all its details.

The stage of colour filling was traditionally referred to as *amal, rangamezi* or *gadkari*. In between the careful application of successive colour coats, the *vasli* was repeatedly burnished to ensure that the pigment

particles settled compactly and got enmeshed with the paper. It imparted to every colour an enamel-like brilliance and created an even surface, ideal for the next stage of minute stippling (*pardaz*) in matching darker tints. Charred tamarind twigs were used for drawing the sketches. Brushes were made by fitting the squirrel hair into feather quills.

The traditional binding media with which the pigments were tempered was gum arabic (*babul ki gond*). The pigments may be placed into two groups, namely, organic and mineral. The white (*safeda*) imported from Persia for the Mughal atelier was probably lead white, though at a later stage zinc white was also included. Lamp black as well as carbons of animal, mineral or plant origin was used from very ancient times for painting and calligraphy. The warm and dense Indian red (*geru*), the purplish red ochre (*hormuzi*) from Hormuz, the commonly used orange lead (*sindura*) and vermilion (*ingur*) or the sulphide of mercury were the main shades of red used. The lac-dye (*alta*) and the red insect dye-stuff (*krimdana*) were both organic pigments producing carmine. For blue, the mineral lapis-lazuli (*lajvard*) and azurite were prescribed traditionally, while indigo (*nilabari*), a dye-stuff derived from the indigo plant was also tried. Indian yellow (*peori*) used to be the fine sediment, separated from the urine of cows fed only on mango leaves. A chemical analysis reveals this to be magnesium or calcium salt of euxanthic acid. Gamboge yellow was an organic

pigment extracted from a gum known as *sare revan*. Yellow ochre (*ramraj*), known for its opaqueness was of mineral origin. The green earth (*hara dhaba*), was the

Below Left

A Kota painter, c. 1780; 26.7 x 13.6 cms. National Museum (No. 47.110/923). The painter is drawing the sketch of a female figure on a vasli *placed on his raised knee drawings.*

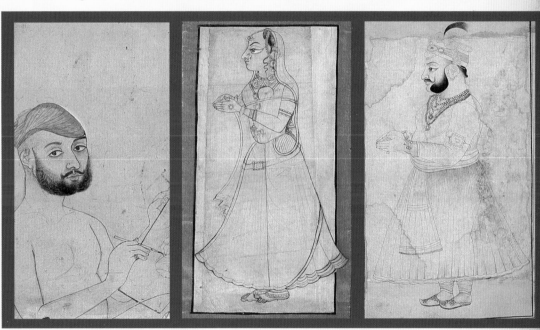

Above Centre

A female worshipper from Kota, c. 1820; 37.8 x 20.7 cms. S.S. Backliwala Collection. This seems to be a master drawing with pricked outlines for further versions.

Above Right

Portrait of a Kota noble, c. 1840; 38.6 x 23.9 cms. S.S. Backliwala Collection. This standing portrait was finalized at the monochrome level like many Mughal drawings.

hue chosen by the late 17th and early 18th century Mughal painters, who applied generous washes of it to fill up the background of the portrait studies. A bright, grassy green (*dana pharang*) was derived by finely powdering malachite, a colour-producing mineral compound. Verdigris (*zangal*), or the acetate of copper, yielded the emerald green colour which had a natural tendency to darken and to produce brown stains in most cases.

The method of using beaten gold foils (*sona tabak*) and powdered gold (*sona hallkari*) was known to the illuminators of the pre-Mughal era. The two Persian heads of the Mughal atelier were indeed master technicians and they initiated the trainees into the secrets of this art. For finer ornamentation, the areas in gold were tooled with a needle point and the process was generally referred to as *suikari* (lit. needle work). For getting the raised effect (*munavvat*) seen in the pearl jewellery, pottery pieces were rubbed to form a smooth paste which was then applied bit by bit in feather-light strokes. The Basohli painters fixed minute cuttings of beetle wings to parts of the painted jewellery to create an effect of encrusted emeralds.

Chiteri, *or the lady painter, painting a portrait. Mughal, c. 1630; 19.2 x 23.1 cms; Bharat Kala Bhavan (No. 682). This rare depiction of a lady painter at work in the ladies' quarter confirms the involvement of women in the art of painting.*

*The boat of love. Kishangarh, c. 1750;
43 x 33.5 cms. National Museum
(63.793).* **(see page 90)** *Set against a
charming evening sky the composition
has subtle horizontal divisions in tiers.
Overpowering late-Mughal influence
may be located in the tiny figures of
Krishna and herdsmen near the hillock.
Strong white and pink marble
architecture is like a dividing line.
Further below, Krishna enjoys the boat
ride with the lotus-eyed companions in
Yamuna washed in translucent grey and
grown with lotuses. The culmination of
the love-game is the secret meeting of
the divine lovers in the bower. Minutely
finished in molten olive and viridian
green each foliage structure looks
splendid. The ochre tinted grass green of
the plantation trees, lined up on both
the sides of the bower, stand out
perfectly with minutely stippled veining
of the leaves.*

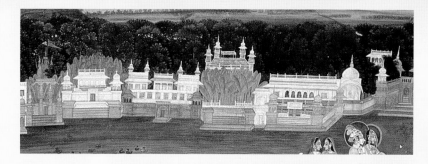

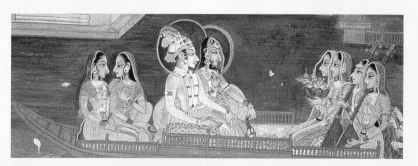

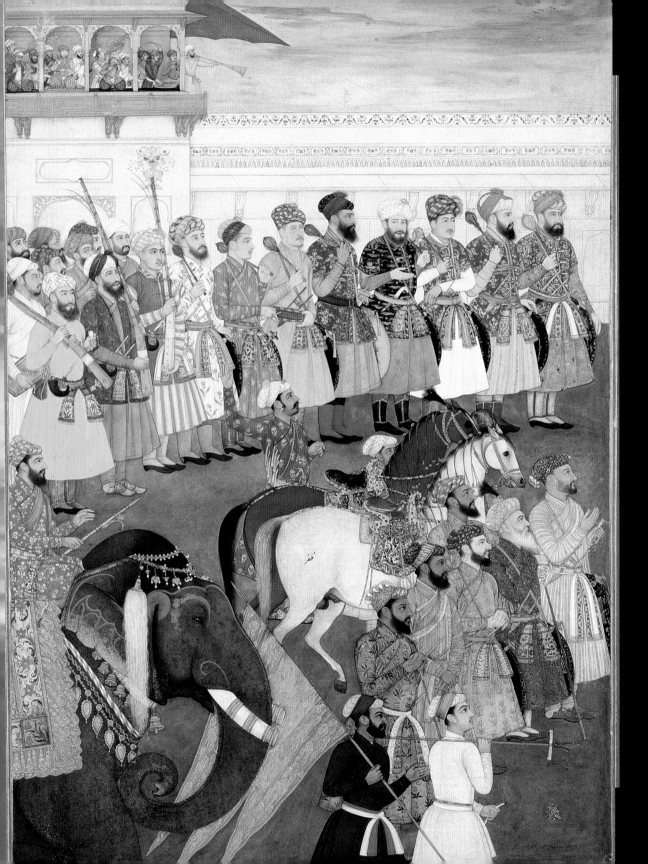

MUGHAL PAINTING

The evolution of Mughal miniature painting, which roughly spanned three centuries, marked a colourful phase in Indian cultural history. Closely related to the emperors' personalities and years of their active connoisseurship, it represented distinctive aristocratic high culture. An impressive range of painted visuals supplements the wealth of details from memoirs, chronicles and travellers' accounts, to make for a richer experience of the proverbial grandeur of the Mughal court.

Vandalized and scattered during the 18th century, the illustrated manuscripts and albums of paintings stored in the imperial library (shahi kitabkhana), were further dispersed in the 19th century and eventually found their way into private and public collections all over the world.

The founder of one of the largest pre-modern centralized states, Zahiruddin Mohammad Babur was a man of exceptional sensitivity. His insightful accounts of flora and fauna with a meticulous concern for detail, remain recorded in his celebrated memoirs *Vaqiat-e-Babri*, the first true autobiography in Islamic literature. Existence of a certain kind of painting tradition during his reign at Kabul can be supported by the construction of a *Surat-khana*, a gallery with painted walls, which he commissioned sometime between 1504 and 1519 in a 'Plane-tree Garden.' A passage from his memoirs is typical of his poetic expression and aesthetic conceptions alluding to the primacy of nature:

> The next morning ... we visited the *Bagh-e-padshahi* (Imperial Gardens) ...One young apple tree in it had turned an admirable autumn-colour; on each branch were left five or six leaves in regular array; it was such that no painter trying to depict it could have equalled.

> (tr. Chahryar Adle)

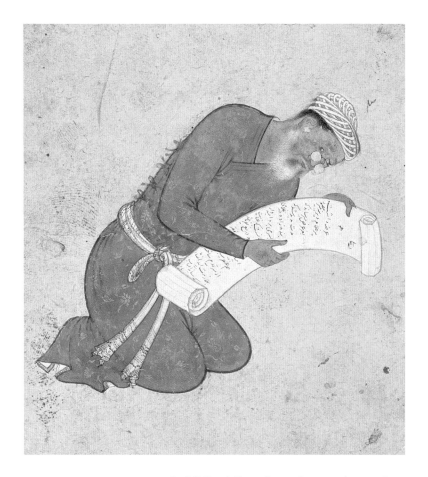

critical summing ups of the two legendary Persian painters, namely Kamaluddin Behzad aud Shah Muzaffar. Babur praised Behzad's delicate techinque but did not approve of the beardless face which he drew by lengthening disproportionately the 'double chin.' At the same time he speaks highly about Muzaffar's delicate representation of floral and animal motifs outlined in gold.' Notwithstanding such a remarkable deepening in the appreciation of painter's craft he could never emerge as a patron of painting during his four hectic regnal years (1526-30) in India.

Babur's eldest son Nasir-ud-din Muhammad Humayun (r. 1530-40 and 1555-56), the luckless inheritor of the Mughal Empire, remained somewhat politically ineffectual; his career alternated between successes and setbacks. Philosophy, astrology, poetry and music were his main diversions. A lover of books like his Timurid ancestors, he also developed a taste for painting early in his life and had artists in his service before 1540, when he was driven from India by Sher Shah Afghan. Even during his four fruitless years of wandering in Sind he had his mobile library transported by camel. Finally, the royal exile took refuge in the Safavid court of Shah Tahmasp II (r. 1524-76) at Tabriz. It was here that he was exposed to the full panoply of the Persian bibliographic tradition and saw the choicest examples of calligraphy and painting.

A Vizier delivers the petition of Mir Musavvir to Humayun. By Mir Sayyid Ali. Mughal, c. 1555-70; 12 x 11.1 cms. Musée Guimet (No. 3619-1b).

A bibliophile of modest order, Babur indeed had a library with a functioning scriptorium. He also mentioned the name of Maulana Mohammad Mozahheb, the gilder and ornamentalist several times in his memoir. Once belonging to Timur's grandson, Prince Mohammad Juki, an illustrated copy of *Shahnama*, ranking among the greatest illustrated versions of the epic belonged to Babur's library, was handed down to later Mughals as a precious heirloom. Equally interesting is his brief

Shah Tahmasp, who 'fell prey to his own stinginess' and became increasingly orthodox, showed a marked disinterest towards the art of painting. Initiated into the inner significance of Persian pictorial conventions, Humayun cherished a desire to have a similar assembly of poets, writers, philosophers, painters and calligraphers. His re-establishment in Kabul (1545) was largely aided by the Safavids. At his behest, two reputed painters of Shah's royal atelier, Mir Sayyid Ali of Tabriz and Khvaja Abd us-Samad of Shiraz, arrived at Kabul on 1 November 1549. Till 1555 they were engaged in preparing some highly finished single-page compositions, book illustrations and calligraphic pieces (*qeta*) in the transplanted Safavid style. Abd us-Samad became a close friend of Humayun and the latter conferred on him the title *Shirin Qalam*, 'the sweet pen.' Contemporary chronicles affirm the presence of a few other master painters, namely Dust Muhammad and Maulana Yusuf, the disciples of Behzad and Maulana Darvish Muhammad a pupil of Shah Mazaffar. Dust Muhammad, Mir Sayyid Ali and Abd us-Samad accompanied the emperor when he left his interim capital for India in 1554. Mir Musavvir, the distinguished painter in the royal atelier of Shah Tahmasp also came to India with his son Mir Sayyid Ali. The emperor was attracted to the placid visual imagery of Mir Musavvir and requested Shah Tahmasp to spare the services of this artist, for one thousand *tumans*. Following the reconquest of Delhi in 1555, Humayun had a fatal fall from the stairs of his library. The nobles of the court agreed to crown his son Akbar, who was thirteen years and a few months old, with the title Jalal-ud-din Mohammad Akbar.

'Rather than a physical site,' Akbar (r. 1556-1605) himself was the capital of his multi-regional empire. Consolidation of the imperial authority and the implementation of a centralized administrative system, posed a challenge to his many-splendoured personality. He was quick to understand the two essential strands of political centralization, namely, 'a reliable imperial elite' for the proper functioning of the court and the 'local aristocracies' to have ties with the countryside. At his new citadel, Fatehpur (City of Victory) at Sikri, he satisfied his creative impulses by patronizing music, painting, the art of calligraphy and poetry. His interest in the arts could be traced back to his lessons in the basics of calligraphy and painting, the essential social graces for a Timurid prince, that he had received as a young boy from Abd-us-Samad and Mir Sayyid Ali. Incidentally, illustrated books belonging to the personal library of his mother, Empress Hamid Banu, have also survived.

As has been recently suggested, Akbar's genius was distinguished by his affliction of dyslexia. Partly because of

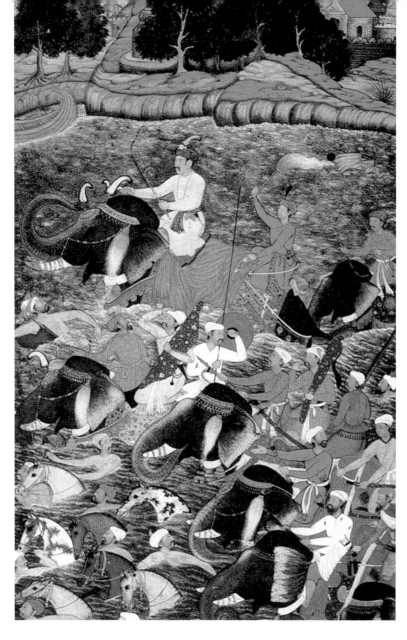

Akbar crosses the Ganges astride elephants. By Ikhkas. Faces by Madhu, Mughal, Akbarnama Ms. 33 x 18.3 cms, c.1588-90

in the manuscripts. This factor perhaps enhanced Akbar's early interest for illustrated copies of the text.

Akbar, an ardent believer in cultural and religious synthesis, had a remarkable catholicity to brush aside the prevalent Islamic orthodoxy and to look at the art of painting, as 'an antidote against the poison of ignorance.' Once in a private gathering of elites he expressed rather emphatically:

> There are many that hate painting; but such men I dislike. It appears to me as if a painter had quite peculiar means of recognizing God; for a painter in sketching anything that has life, and in devising its limbs, one after the other, must come to feel that he cannot bestow individuality upon his work, and is thus forced to think of God, the giver of life, and will thus increase in knowledge.

> (*Ain-i-Akbari,* tr. H. Blochmann, p. 114-5)

Investigating the aspects of the natural world became a quintessential feature of Mughal painting. This concept was different from the indigenous cultural attitudes of pre-Mughal times. The interest of the painters in minutiae proved radical. The portrayal of facial features throbbing with vital energy enhanced the impact of the narratives. Independent compositions for the albums were also made of which portraits (*shabih*) of courtiers and grandees of the realm display a passionate enquiry

this he had 'an amazing retentive mind as well as universal curiosity.' He enjoyed being read to regularly and at the page the readers would stop for the day, he made 'a sign' with his own pen. Such reading sessions of story tellers (*qissa khwan*) were possibly enlivened by the suitable visuals

into the specific appearance and personality of the sitter. Abul Fazl's note regarding the development of portraiture is indeed revealing:

> His Majesty himself sat for his likeness, and also ordered to have the likenesses taken of all grandees of the realm. An immense album was thus formed: those that have passed away have received a new life, and those who are still alive have immortality promised to them.
>
> (*Ain-i-Akbari*, tr. H. Blochmann, p. 115)

The first great project undertaken around 1557-58 by the artists of Akbar's atelier, under the supervision of Mir Sayyid Ali and Abd us-Samad, was the illustration of *Hamzanama*, (a collection of adventurous stories of Amir Hamza, the Prophet's uncle). It took some fifteen years until c. 1572-73 to complete fourteen hundred large-sized paintings on mounted cotton, having a tight weave. Recently, a scholar has suggested that each set of hundred painted folios was stored in a box, protected by an oversize portfolio. Paintings were displayed during the public recitations of the story (*qissa*). The text, supporting the paintings was put on the paper backing of the next painting. Some hundred odd painters were recruited from the pre-Mughal centres of painting to be trained under Tabriz masters (*ustads*) for the *Hamza* project and to meet Akbar's ever-growing demand for illustrated

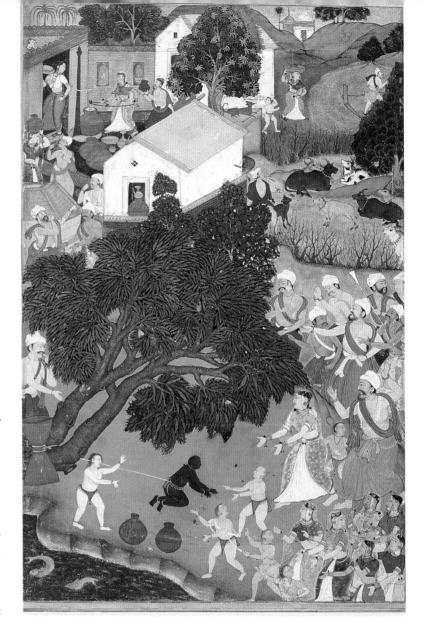

manuscripts. This 'wondrous book', according to contemporary chroniclers was 'one of the astonishing novelties' that His Majesty conceived of. It is regarded as the earliest major manifestation of the Mughal idiom. Any 'evolutionary hypothesis postulating a development'

Krishna tied to a mortar, uproots the twin Arjuna trees. Mughal, Harivamsha *Ms., c. 1590; 27.9 x 18.5 cms. Victoria & Albert Museum (No. 15:2-1970).*

from the 'archaic' to the 'refined' or from 'the proto-Persian to the fully Mughal' may not be applicable here. Apparently painters with widely varying talents were simultaneously at work. The fusion of the refined lyrical Persian style with the intensely symbolic pre-Mughal traditions of north India, Rajasthan and even the Deccan is seen. Precise outlining *(arqam)*, gem-like colours and refinement of tonal values were the traits imbibed from the Persian style. A suggestion of spatial dimension was coupled with rendering of trees in free and visible brushwork. A mood of turmoil and excitement characterizes the entire series. The gesticulating figures are struck by an innate sense of wonder. The treatment of water in swirling eddies, flecked with foam and inhabited by large playful fish, crocodiles, turtles and imaginary sea-monsters eventually became a convention of the style. A preference for warm vermilion, yellow, dark green and rich chocolate is indeed expressedly closer to the *Chaurapanchashika* group.

Gradual refinement of painterly technique and the extension of the range of subjects characterize the Akbari style of the 1580s. Most of the paintings bear the scribal notes of the record-keeper of the *tasvirkhana*, the royal painting bureau. The ascriptions are followed by the nature of work each artist was involved in, namely *tarrahi* (sketching), *rang amezi* (colouring) and *chehranami* or *chehrakushai* (revealing faces). As against these 'third person

ascriptions,' signed creations of Akbar's atelier are indeed a rarity. The signatures of Khvaja Abd us-Samad and Kesu dasa are, however, the outstanding exceptions.

The Safavid norm of collective execution was imitated to facilitate a fast and high quality production of miniatures. The extent of collaboration in a painting was usually limited to two or three painters. Masters *(ustads)* were entrusted with the task of visualizing the composition and making the initial drawing *(tarh)* while trainees *(khurd)* were engaged in filling the colours *(rang-amezi* or *amal)*. A third painter, highly trained, was occasionally included for 'revealing' the faces *(chehranami/ chehrakushai)* and the final touch to the entire compostion was given by the masters. Such a division of labour seldom failed to complement each other perfectly. Perhaps this was due to the painters' practice of referring back to known visual resources for painting human figures as well as for landscape, architecture and fauna. A decrease in the demand for illustrated manuscripts in the early decade of the 17th century and growing interest in the individual painter's style made the 'efforts of joint studio production' less viable.

The preparatory drawings, tracings and pounces *(charba)* stored in the workshop were available for re-creation. Finished pictures in the library also fed the artists' enquiries for every painterly detail. Accumulations of *materia technica* in the

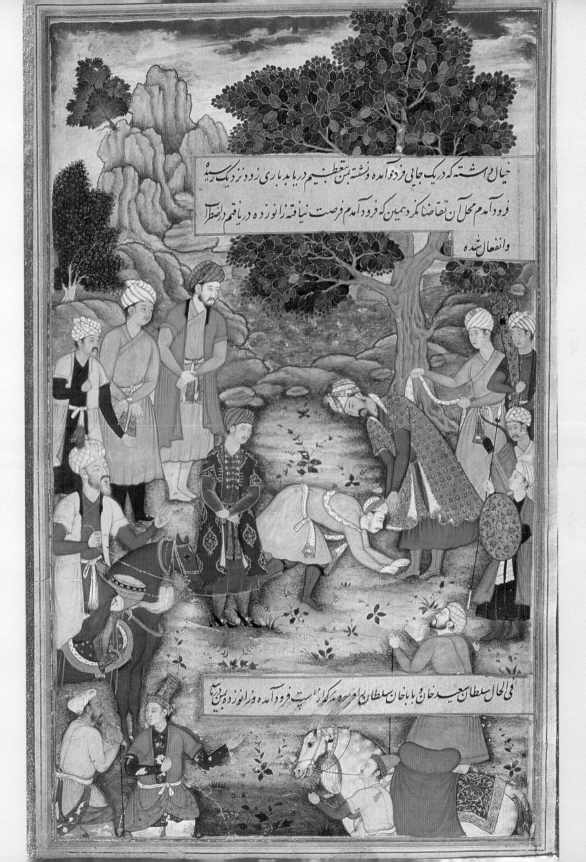

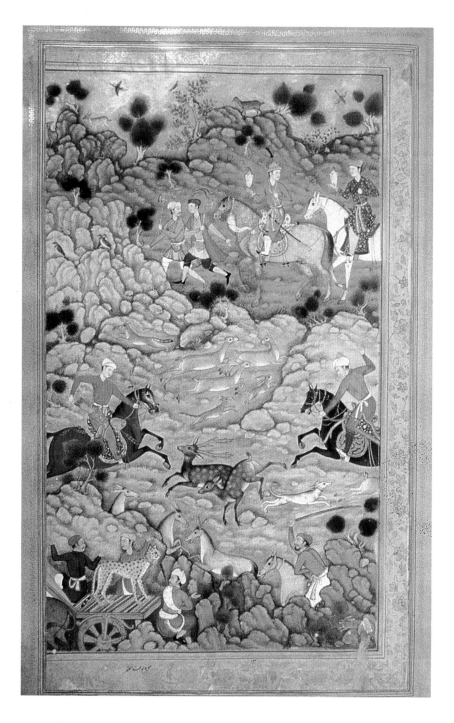

atelier, invariably included examples even from exotic sources like Persia and Europe. Jesuit and Dominican missionaries visited Fatehpur Sikri several times between 1580 and 1605. Among the gifts they brought for Akbar in 1580 were seven of the eight volumes of *Biblia Regia* or the Royal Polyglot Bible. Also known as *Plantiana* after the printer Christopher Plantin, the Bible was printed in Antwerp between c. 1568 and 1572 at the request of Prince Philip II of Spain.

Title pages of the Bible engraved by Flemish artists such as Pieter van der Heyden, Pieter Huys, Gerard van Kampen and the Wierix brothers became materials to study and copy. A calendar by Hans Sebald Beham (1500-50) and Bartel Beham (1502-40), German engravers of Nuremberg, also reached the Mughal atelier. Among the second group of European prints that remained a source of inspiration for painters like, Basavan, Miskin and Kesu dasa, were the late-16th century prints from the Antwerp Guild. Engravings of Albrecht Durer (1471-1528), 'the Apelles of black lines', and those of Sadeler brothers came via Antwerp, a key centre of book production in the 16th century. A steady inflow of European printed books with engravings, painted tapestries and other decorative objects continued to constantly enlarge the dimensions of Akbari painting.

In his chronicle, Abul Fazl listed only seventeen artists and discussed the style

of only four major designers. Some painters came from far and near to work in the royal workshop and their origin is obvious in the second part of their name. Bhimji *Gujarati*, Nand *Gwaliori*, Ibrahim *Lahori* and Haidar *Kashmiri* are a few such names, however not included in Abu Fazl's list.

Amidst the broadminded elite encircling the emperor, there were patrons of art like Abdul Rahim Khan Khanan and Raja Man Singh, Ilhavardi Khan, Munim Khan and Mirza Aziz Koka. Abdul Rahim Khan Khanan 'a dervish in the guise of a prince' was one of the 'Nine Jewels' *(navratan)* of Akbar's court. 'Giving' was his 'second nature' and his legendary generosity helped transform the lives of many artists and poets. Mirza Aziz Koka *(koka*: the foster brother) besides being a poet, had a remarkable sense of history. A favourite playmate of young Akbar and a close associate all along, he was initiated into the calligraphic flourishes of the *nastaliq* script early in his life by Muhammad Baqir. Their ateliers had painters and calligraphers belonging to a less sophisticated cluster of the Imperial workshop. Akbar encouraged such sub-imperial patronage and gifted copies of manuscripts based on his imperial model to nobles who received them with 'the blessing and favour of God.' The development of 'Popular Mughal' idiom during the late-16th and early-17th century makes an interesting study in

itself. These paintings, strongly expressive and animated, very often revert to the Pre-Mughal types of composition.

Over time, Akbar's interest shifted from the fanciful idealism of *Hamzanama* and the contemporary *Tutinama* towards more serious texts. Persian poetic classics, histories, biographies and translations of traditional Indian texts were taken up for illustration. For the Hindu painters, who outnumbered their non-Hindu colleagues of the atelier, the illustrations of the epics *Mahabharata* and *Ramayana* became recreations of the deeply-etched visions of the myth. The front-ranking painters of the studio illustrated the translation of *Mahabharata* entitled *Razmnama* (The Book of Wars) between 1582 and 1586 for the imperial library. *Razmnama* was followed by the Persian translation of the *Harivansha Purana* (A Chronology of the *Yadavas* and the deeds of Krishna) in 1586, *Ramayana* in 1589 and *Yoga-Vasishtha* (The Yoga-teaching of Vasishtha) in 1598. The dynastic histories included *Tarikh-i-Khandan-i-Timuriya* (The History of the Timur Clan), *Tarikh-i-Alfi* (The History of One Thousand Years), *Shahnama* (The Persian Book of Kings), *Darabnama* (The Tales of Darab) and *Baburnama*, (Persian translation of Babur's autobiography). The illustrations of these texts have a strong element of realism supported with a plethora of studied detail. The culmination of this approach was undoubtedly in the

Facing Page

*Coronation of Rama.
Sub-Imperial Mughal,
Ramayana Ms.,
c. 1600; 29.7 x 19.4
cms. National Museum
(No. 56.93:1).*

illustrations of the *Akbarnama* (c. 1590s), the history of Akbar's reign by Abul Fazl. The painters of the *Akbarnama* concerned themselves intensely with contemporary realism and strove to recapture the topography as well as the exact situation narrated. The poetical manuscripts, some of which were prepared for the emperor's personal delectation, comprise of *Gulistan* (Rose Garden) of Sadi, *Khamsa* (The Five Poems) of Persian poet Nizami, *Baharistan* (The Garden of Spring) by Jami and *Divans* (Collected Poems) of Hafiz and Anvari.

The artistic career of Mir Sayyid Ali, (born c. 1513, his *nom de plume* Judai) the the painter and poet 'with a mystical strain of Sufi inspiration', falls into two phases: his early years at the Safavid court in Tabriz and his period of service at the Mughal atelier of Humayun and his son. The *Hamza* project began under him and he remained in charge of it till c. 1572. True to the vocation of art *(hunar),* he perfected the technique *(fann).* As early as c. 1530, he was chosen to assist Sultan Muhammad, 'a painter of unusual talent and subtlelty', on the great *Shahnama* executed for Shah Tahmasp. A skilled calligrapher, his brush-strokes display flow and vigour. Gifted with an extraordinary visual memory, his attention to an abundance of descriptive details extending beyond narrative necessity of the figural compositions was all but compulsive. His sketching of the texture of the costumes, ornaments and still-life was admirably studied. The key aspect of his aesthetic attitude, that 'this world is a mirror of the divine world' conformed to the norms of the Akbar's atelier.

A close study reveals that Persian elements predominated during the development of Mughal painting. Abd us-Samad took over charge of the atelier as director in c. 1572 and trained painters like Dasavanta and Basavan. Even he adhered closely to the Persian idiom and continued to remain unaffected by 'the full blown movement, plasticity and psychological insight so typical of the Mughal style' till much later. Placidity, dispassionateness and clarity in execution were some of his virtues. *King Khusraw Hunting,* the latest signed and dated work of the master, reveals a preference for darker tonalities, with each rock cluster being accentuated with sandstone tints and greys. The movement of the galloping gazelles in opposite directions is central to the high-keyed lyricism permeating the entire composition.

Basavan's style was marked by a 'characteristic emphasis on the painterly rather than the linear.' His career, spanning roughly four decades reached maturity by the 1580s. Apparently, he remained active as late as c. 1615, becoming master-designer *(tarrah)* after Abd us-Samad was appointed Finance Minister *(divan)* of the province of Multan in 1588 A.D. Compared to the strong imaginative expressions of Dasavanta, Basavan's approach was

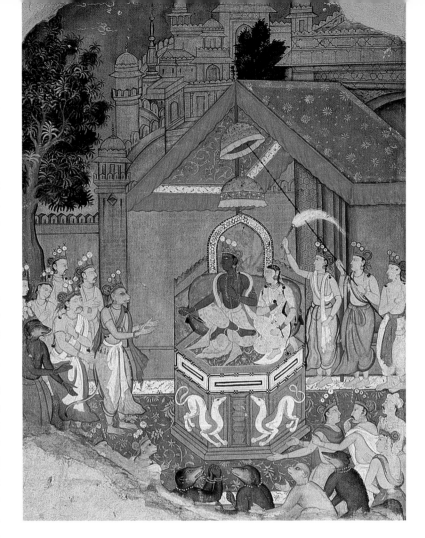

essentially rational. Even in the early phase he rarely worked as a simple colourist. Invariably, he was responsible for the 'skilful layouts' as also the portraits *(chehrakushai)*. His capacity 'to suggest recession and roundness of form' and conceive 'designs in depth' may safely be linked to his interest in European prints.

Though 'perspective as a science' was never mastered by the Akbari painters, almost all of them superficially blended linear perspective with the aerial, to enhance narrative continuity. The compositions thus became complex, marked by 'overlapping diagonals.' Basavan also sought to recapture the grisaille effect of the European engravings in his monochromatic studies, referred to as *nim-qalam* or *syah-qalam,* in black, umber and burnt sienna. Lines were supported with soft layers of washes. They were further relieved with stippling *(pardaz)* done with parallel lines *(khat pardaz),* crossed lines *(jalidar pardaz)* or simply with dots *(dana pardaz).* During the last years of Akbar this technique was much admired. His son, Manohar was born in the late 1560s. His career spanned the years 1582 to c. 1620, and he learnt under his father for about a decade. By the 1590s, he had moved away from Basavan's style. He preferred colourful compositions, which stressed surface designs rather than spatial values and which glorified courtly pomp and magnificence. Manohar later emerged as a keen portrait painter of Akbar's reign. In the following era he was probably the first to master a closely related genre, the historical group portrait.

Kesu dasa or Kesu Kalan (Kesu the Elder), was another painter of eminence. He was apparently active until the end of the 1590s. His style was marked by uncontested technical mastery, highly detailed rendering of distant landscapes and deft handling of the human figure. Invariably, he signed his creations in obscure areas on the painting, such as 'a

The hesitant maiden being tactfully led to the Prince. Late Mughal, c. 1720; 38.7 x 27.5 cms. National Museum (No. 79.195). An impatiently waiting prince tosses on the bed having a brocaded lily pool on the border. A celebration of white enhances the poetry of a moonlit night.

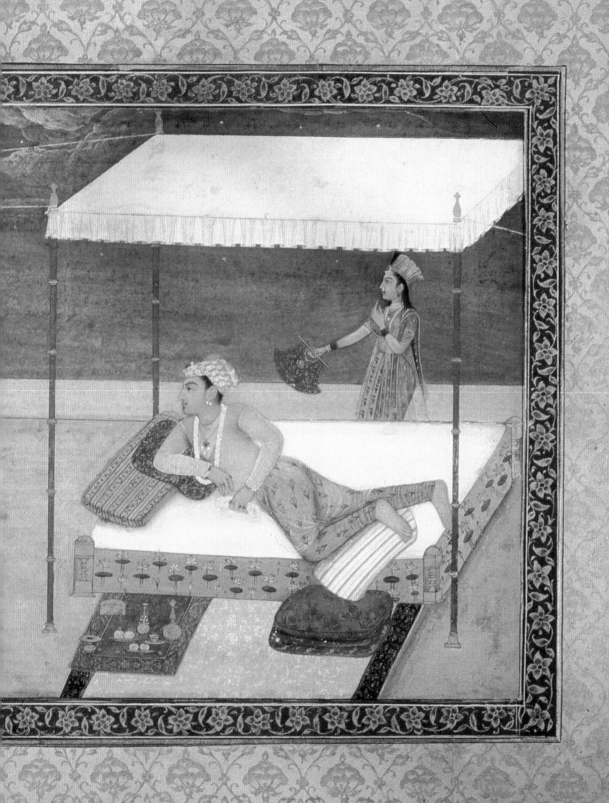

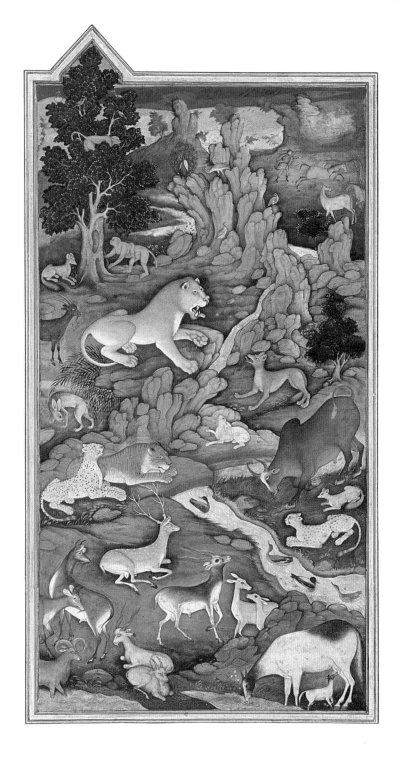

ewer', 'a gilded vase' or 'the knotty branch of a large tree'.

Miskina, one of the superlative artists of the Akbari atelier, was the son of master painter Mahesh. He was active between c. 1580-1600. By c. 1585 he was commissioned to design some of the crucial episodes in the illustrated histories under preparation namely, *Akbarnama*. He was exceptionally skilled in the portrayal of animals. Typical of Miskina's vocabulary is 'a hill goat clambering up some rocks' or 'a fox appearing from behind a group of trees', or 'an exquisite yellow bird on a tree-top.'

In 1585 the capital moved from Fatehpur Sikri to Lahore. The painting of the 1580s and 1590s exemplifies a mature eclectic style with elements, Persian, Indian and European, deftly grafted into 'a balanced harmonious whole.' The detailed treatment of the background and the suggestion of receding space were the two notable stylistic traits of this phase. The painters found a solution to the problem of spatial projection through European examples and repeatedly painted the distant views of towns set on craggy hills, winding roads, lakes or riversides, dipped in a bluish haze. Such passages seem hard to rationalize with the rest of the composition, which was conceived in bird's eye-view. Harsh shadows often counter-balanced the areas treated softly but they never conjured up a planned *chiaroscuro*. The trees with carefully stippled

mass of foliage, derived from Flemish models, looked voluminous. Piles of rocks, painted in pleasant shades of grey, pink, brown, lemon and dull mauve, slowly led the eye along the receding planes. The line continued to be the primary means of defining mass, while the colours and the tonal modulations were partially complementary.

Akbar returned to Agra in 1598, after fourteen years. The rebellious attitude of Prince Salim, the heir-apparent, embittered the emperor during his last years. In 1600 the prince left the court for Allahabad, with his entourage of painters including Persian masters Aqa Riza, his son Abul Hasan, Mirza Ghulam and a few trainees. Curiously enough, the works produced at Allahabad and in Akbar's studio at Agra after his return from Lahore share certain common pictorial ideas. A growing interest in portraiture was followed by an enlargement of the principal figures in proportion to the total painted area. Both father and the son at this stage started compiling *muraqqa* (patchwork album) with a wide variety of works. Creations of the renowned Persian painters, European prints and examples of Deccani painting were carefully mounted alongside contemporary and early Mughal non-narrative paintings. Elaborate *hasiyas* (borders), sumptuously designed with floral and arabesque patterns, considerably increased the effect of such examples.

Salim ascended the throne with ceremony and assumed the name Jahangir (The World Seizer) and the title of Nur-ud-din (Light of the Faith). In the reign of Jahangir (1605-27), the warmest and the most cultivated of the Great Mughals, the imperial studio contracted to an elite band of painters. They attended the emperor both in court and camp and were relentlessly coaxed to come up to the patron's immaculate standards. Painters unable to achieve the desired level of refinement were set free to search for other alternatives at the sub-imperial level or look for popular patronage. Some were active at Agra whereas those who left for Deccan or Rajasthan were, indeed, instrumental in spreading the Mughal elements far and wide.

Jahangir's interest was different from his father's. 'The interest,' as the critics have pointed out, 'was transferred from the practical applications of painting towards the heights that painting as an art could achieve.' Recreation of historic times or an enquiry into the subtle notes of a myth, felt the passionate naturalist, were not the best vehicles for the full flowering of a painter's virtuosity. The subjects a painter selected often had a pronouncedly personalized association, often 'as quirky as his memoirs,' *Jahangirnama*. The trend of manuscript illustration slowly gave way to sumptuous production of *muraqqas*. The sequential relationship between such album paintings was merely generic. The art of portraiture, started under Akbar was

especially promoted. Painters paid great attention to the individuality as well as to the psychological aspects of the character portrayed and gradually even the lingering traces of convention were sacrificed for the sake of lifelikeness.

Jahangir's 'intimately confessional and touchingly honest' autobiography, *Jahangirnama* enables us to appreciate his aesthetic sensibility and his innate fascination for zoological and botanical peculiarities. Remarkably confident about his keen discrimination he wrote in his Memoirs:

I derive such enjoyment from painting and have such expertise in judging it that, even without the artist's name being mentioned, no work of past or present masters can be shown to me that I do not instantly recognize who did it. Even if it is a scene of several figures and each face is by different masters, I can tell who did which face. If in a single painting different persons have done the eyes and eyebrows, I can determine who drew the face and who made the eyes and eyebrows.

(*Jahangirnama*, tr. W.M Thackston, p. 268)

Two major painters of Jahangir's atelier were Abul Hasan, (active between 1600 and 1628) and Ustad Mansur (prominent between 1589 and 1628). Abul Hasan, a left-handed child prodigy, described himself as a *khanazad* (palace born) or *kamtarin muridzada* (the humblest of the sons of the imperial disciple). The observations made by the emperor in his thirteenth regnal year is a rare tribute paid by a Mughal emperor to his favourite artists:

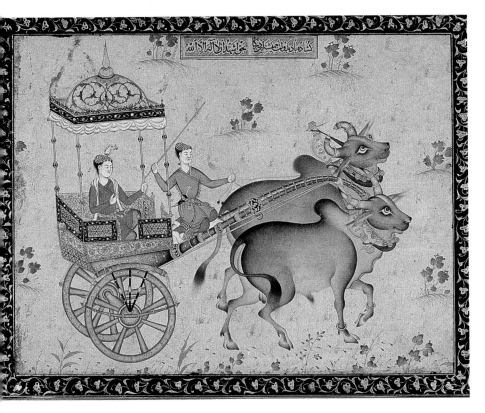

On this date Abul Hasan the artist, who had been awarded the title of Nadiruzzaman (Rarity of the Time), presented a painting he had made for the opening page of the *Jahangirnama*. Since it was worthy of praise, he was shown limitless favour. Without exaggeration, his work is perfect, and his depiction is a masterpiece of the age. In this era he has

no equal or peer. Only if Master Abdul-Hayy and Master Bilzad were alive today would they be able to do him justice. Abul Hasan's father was Aqa Riza of Herat, who joined my service while I was a prince. Abul Hasan therefore is a *khanazad* in this court. His work, however is beyond any comparison in any way to his father's; they can't even be mentioned in the same breath. I have always considered it my duty to give him much patronage, and from his youth until now I have patronized him so that his work has reached the level that it has. He is truly a rarity of his age. So is Master Mansur the painter, who enjoys the title *Nadirul'asr* (Rarity of the Age). In painting he is unique in his time. During my father's reign and mine, there has been and is no one who could be mentioned along with these two.

(*Jahangirnama*, tr. W.M Thackston, p. 267-8)

Abul Hasan happily combined the ornamental grace of Persian painting with contemporary realism and excelled in dynastic portraits. The significance and beauty of his style rested on 'a brilliance of technique' and an 'integral sympathy for subject presented.' Starting modestly in Akbar's atelier as a *naqqash* (a decorator of borders), Mansur picked up the required technical intricacies under the tutelage of masters like Basavan and Miskin, and specialized in the depiction of animals, birds and flowers. Quite contrary to Abul Hasan's painterly treatment,

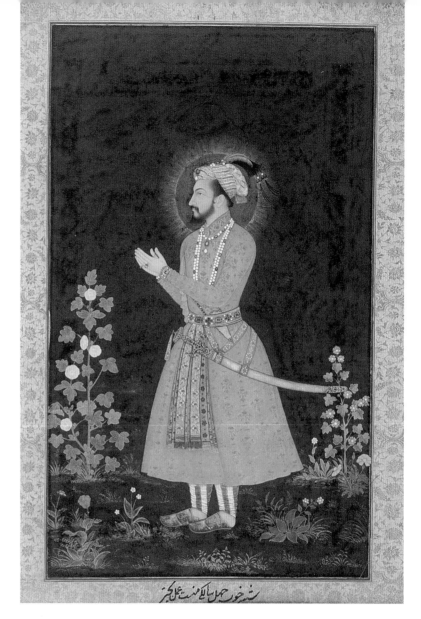

Mansur's style was marked by a strong draughtmanship. His natural history drawings done with highly controlled use of supple lines and thin layers of pigment applied with wet strokes on uncoloured paper offer a remarkable 'scientific precision.' In 1620, Jahangir, enraptured at the exuberance of spring time flowers

Shahjahan. By Bichitr. Mughal, dated 1631; 26.1 x 17.5 cms. Victoria and Albert Museum (No. 1M:17-1925).

of Kashmir commissioned to Mansur the floral studies which numbered 'more than a hundred.' Flowering plants, used as decorative motifs par excellence in the eras to follow, possibly had their root inspiration in such brilliant studies. Another leading painter of the period, Bishandas, was 'unequalled in his age for taking likeness.' He was sent along with the delegation to the Safavid court for making the likeness of Shah Abbas, whom Jahangir could never meet in person. Bichitr specialized in painting complex historical subjects and allegorical portraits of the emperor. Muhammad Sharif, son of Abd us-Samad, was one of Jahangir's closest companions and was elevated to the rank of Grand Vizier. Among the painters who contributed to the innovations of Akbar's atelier and continued under the watchful guidance of his son were Basavan, Miskin, Manohar (son of Basavan), Daulat, Farrukh Beg and Govardhan.

An avid collector of art, Jahangir's interest in collecting European prints and paintings went back to his days as Prince Salim. The emperor's enthusiasm for the pictures of the Saviour and Blessed Virgin is recorded in the letter of the Jesuit priest Father Xavier. During his stay at Agra, Xavier was consulted frequently to elucidate the Christian iconographic symbolism.

Abul Hasan's softly shaded *nim-qalam* of St. John the Evangelist (dated 1600/01), done when he was just thirteen, based on Albrecht Durer's engraving of 1511 is one of the most aesthetically satisfying renditions. Incidentally, quite a few original engravings were coloured in by the contemporary Mughal painters. One such example bears the signature of Nadira Banu, a female artist claiming Aqa Riza as her instructor. Sir Thomas Roe, the ambassador from King James I of England appeared at the Mughal court in 1615. During his four-years stay he was continually implored by the emperor to arrange for European paintings of secular themes as well as royal portraits. Once, the painters in Jahangir's employment made such outstanding copies of a certain European original gifted by Roe that even he had difficulty discerning the copy from the original.

The portraits of Jahangir in his later years which form a separate genre, are characterized by intentional allegorical glorifications of his imperial image. The roots of such imagery lay in English prototypes of the 16th and early 17th century. In order to emphasize the emperor's achievements the painters conceived of an iconography glorifying the imperial image. Jahangir was shown standing on or holding the globe with a refulgent halo symbolizing 'the massed light of sun and moon.' Bichitr, a master painter, once painted the emperor enthroned on an hour glass with little cupids inscribing that he may live a thousand years. Many such allegorical

portraits highlight Jahangir's much famed justice, represented by the lion and lamb in peaceful coexistence.

Jahangir's patchwork albums *(muraqqa)*, a spectacular testimony to his epicurean and elitist taste, have borders with inhabited arabesques. The technique of using two or three different shades of gold with occasional touches of silver was indeed a late Akbari convention. It gave way to fully modelled birds, beasts and human figures being included in natural colours. Setting off the figures, the gilded portions acquired the character of a background. Aqa Riza Herati was entrusted with assembling the collection into albums.

Following the Persian prototypes, interlacing tendrils *(jush-i-risman)* and animal designs *(janvar-sazi)* were very popular among the pagers. They often turned the *janvar-sazi* into challenging visual puzzles by transfusing into their framework the elements *tarh-i-saqeh-yi-gul* (design of floral stems). A closely related variation was *shikargah* that focused only on the animals and birds chasing each other, devouring their prey or relaxing leisurely in a fantastic landscape. The evolutionary process of borders from Jahangir to Shahjahan period evidences an augmented interest in the floral theme. Recent studies have proved to a certain extent that Mughal flower studies of the 17th century were influenced by the contemporary European *Herbals* namely,

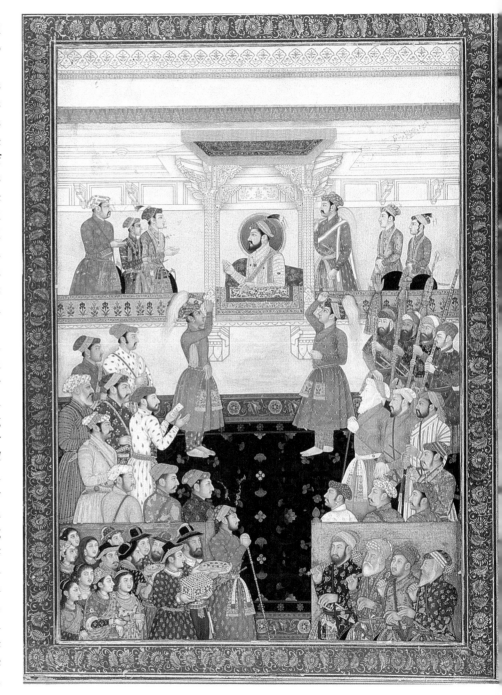

Jahangir, with the imperial orb appearing at a jharokha *(viewing window for official appearances) and Jesus with the cross. By Hashim (above), Abul Hasan (below). Mughal, c. 1618-20; 17.1 x 9.2 cms. Chester Beatty Library (Ms. 7:12).*

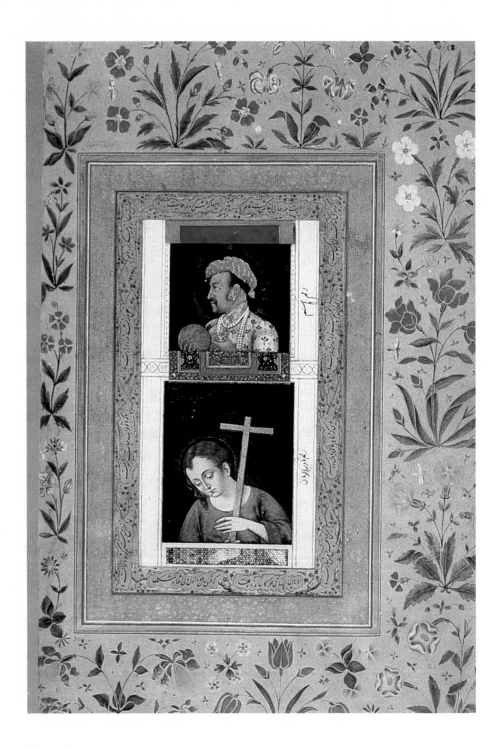

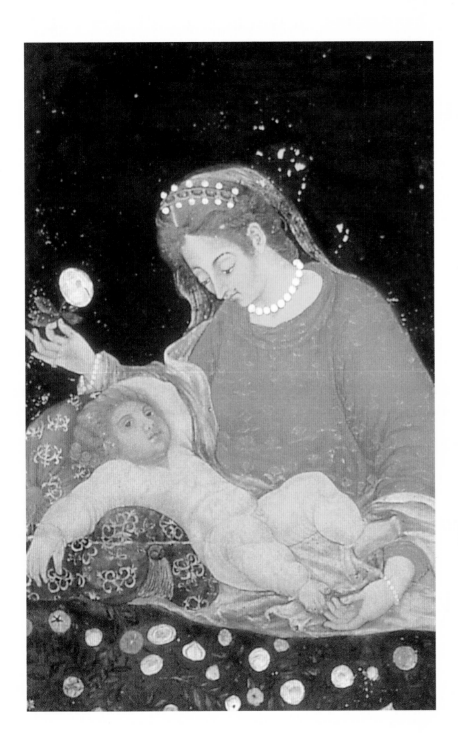

The Virgin and child. Mughal, c. 1630; 13.8 x 10.3 cms. British Library, Oriental and India Office Collections. (14.2). This painting was based on one engraving of Egidins Sadeler (1570-1629), a Flemish engraver of the Antwerp Guild.

those produced by the Dutch family of engravers based in Cologne (c. 1594-1612) headed by Crispin van der Passe (d. 1637).

In 1611, Jahangir married Nurjahan (Light of the World), a classic Persian beauty with creative abilities ranging from costume designing to hunting. Silver rupees bearing her name were minted at his behest and she was bestowed with administrative prerogative towards the conclusion of his reign. The enfeebled emperor died near Lahore on his way back from Kashmir; on a chilly February day Prince Khurram (The Joyous) titled Shahjahan (King of the World) was coronated in Agra.

Akbar's favourite grandson, Shahjahan's expertise in gemmology and his preference for things 'precious and finely crafted' found expression in his first commissioned work, the Peacock Throne, studded with diamonds and sapphires, rubies and pearls worth ten million rupees. A similar inspired connoisseurship was extended to painting and architecture as also to music during his rule (1628-58). In 1632 he ordered the most romantic building in the world, the Taj Mahal on the bank of the river Yamuna at Agra. This mausoleum for his beloved wife Mumtaz Mahal, poetry in white marble enriched with *pietra dura* inlay and Quranic inscription symbolizes the Divine Throne set in Paradise. The other architectural achievements—Red Fort and Jami Masjid—at his new capital Shahjahanabad

(Delhi), served as an arena for great ceremonies, both secular and religious.

Painting during the first half of his reign continued in the tradition of the previous era, but often displaying technically new and expressively innovative aspects. A few magnificently assembled albums, befitting imperial splendour and an illustrated history of his reign, the *Padshahnama* (copied in 1656/57), are the best repositories of contemporary masterpieces. The latter is indeed the last great Mughal historial text profusely illustrated in the grand manner that mirrored the rhetoric of courtly, ceremonial and military victories.

The painters in Jahangir's employ were coaxed to document the physical reality as well as all the wonders surrounding them, doing justice to both inner character and outward appearance. Intrinsically different from such acutely observed studies of nature, the paintings of Shahjahan's period have an expressive weight of their own. Impregnated with an imperial aura, they evoke a harmoniously ordered realm of radiant purity, a perfected image of the world. Informal and yet intensely expressive portraits of dervishes, holy men and Hindu ascetics standing out in marked contrast to the magnificently opulent court scenes exemplify yet another facet of the new aesthetic values.

An interesting development of this period is the *neem qalam* (sparsely tinted) technique of drawing which was already prevalent in the atelier. In the landscape backgrounds of the Shahjahan period there is a remarkable sense of being able to proceed smoothly from the foreground to the distance. At times the eye travels from the main composition into the related scenic depictions on the *hasiya*. Passages of distant landscapes with well-observed tiny details were typical and continued in some of the hunting and war scenes of the Aurangzeb period. Such effects of *dur-numa* (horizontal recession) were more impressionistic, done without any real understanding of the linear perspective. The countryside with plains and architectural details was presented in a less emphatic manner. The sky was streaked with grey, mauve, turquoise and azure. White fleecy clouds, moving in a spiralling direction against a duck-egg sky was yet another feature.

Shahjahan inherited a flourishing atelier consisting of a band of skilled painters some of whom began their careers in Akbar's *karkhana-yi-sarkar* (royal workshop). Govardhan, the most skilled and innovative of them, excelled in the portraits of princes, musicians, dervishes and naked ascetics. Payag's strongly individualistic adaptation of European painting techniques was apparent in the swirl and movement of pigments which he preferred intentionally to create a greater sense of physical substance and *chiaroscuro*. His enigmatic night effects show a dramatic play of light and expanses

of dark shadows worked up in tan and amber. Abid, Balchand and Bichitr, Hashim, Padarath and Murad were equally skilled masters who with a breathtaking technical finesse created some outstanding court scenes and portraits. However, the distinct individuality characterizing the portraits was gradually eclipsed by the mannered, formal approach with its ever-increasing detailing of the texture and patterns of fabrics, horse-trappings, carpet, jewellery and other accessories. The heir-apparent Dara Shikoh (1616-59), a devoted scholar of Persian mysticism and *Vedanta* as well as an accomplished calligrapher, could have purposefully steered the future development of painting had he not fallen victim to the tragic fratricidal feud. In his late teens he employed a handful of painters and commisioned a *muraqqa* for his beloved wife Nadira Banu Begum. Studies of flowers, birds and portraits of youths characterized by tranquil immobility were thoughtfully chosen keeping in mind their prospective owners.

Francois Bernier's account of the Mughal workshop towards the end of Shahjahan's reign reveals the contemporary situation of artists:

> Large halls are seen in many places, called *karkanays* or workshops for the artisans. In one hall, embroiderers are busily employed, superintended by a master. In another you see the gold-smiths; in a third, painters... The artisans repair every morning to their respective *karkanyas*, where they remain employed the whole day; and in the evening they return to their homes. In this quiet and regular manner their time glides away...
>
> (*Travels in the Mughal Empire*, p. 258-9)

In 1658 after imprisoning Shahjahan in Agra fort and deposing Dara Shikoh, Aurangzeb ascended the throne as Alamgir (Seizer of the Universe). During his reign (1658-1707), religious toleration, the cornerstone of Mughal policy since 1560, was replaced by the puritanical orthodoxy in 1680 and this caused a cultural crisis. Though there are some fine portraits and hunting scenes from the early years of his reign, the production of

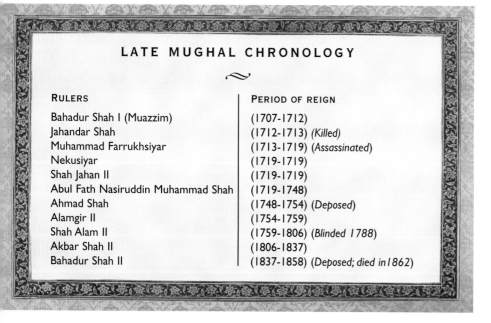

LATE MUGHAL CHRONOLOGY

RULERS	PERIOD OF REIGN
Bahadur Shah I (Muazzim)	(1707-1712)
Jahandar Shah	(1712-1713) *(Killed)*
Muhammad Farrukhsiyar	(1713-1719) *(Assassinated)*
Nekusiyar	(1719-1719)
Shah Jahan II	(1719-1719)
Abul Fath Nasiruddin Muhammad Shah	(1719-1748)
Ahmad Shah	(1748-1754) *(Deposed)*
Alamgir II	(1754-1759)
Shah Alam II	(1759-1806) *(Blinded 1788)*
Akbar Shah II	(1806-1837)
Bahadur Shah II	(1837-1858) *(Deposed; died in 1862)*

illuminated manuscripts had virtually ceased. In terms of style, the tradition of Shahjahan's era continued with a growing inclination towards simplified forms and a palette lacking in modulated tonal values. When religious prohibition on art and financial austerity became the official policy and the entire staff of the royal atelier was virtually dismissed, the artists' patronage broadened to include commissions from the nobles and princes. Some fled to Rajasthan and some to the courts of the Punjab hills. Aurangzeb engaged himself in making copies of the *Quran* and towards the end of his life became regretful of his headstrong decisions.

Aurangzeb's death in 1707 was followed by an alarmingly unstable political era. Power struggles worsened the insecurity of weak-willed rulers, thus causing the rapid dismantling of Delhi's central authority. Painters migrated to provincial courts, creating a wave of Mughal influence and the paintings produced with less technical attention were meant for instant understanding by the patrons from various levels. The later Mughal tradition of painting with the ingrained proclivity for reposeful yet sensuously romantic outlook gradually evolved a certain ceremoniousness superseding the eagerness to discover the poetry of life. The short-lived revival of painting during Muhammad Shah's reign, was a last flash of brilliance lacking in the

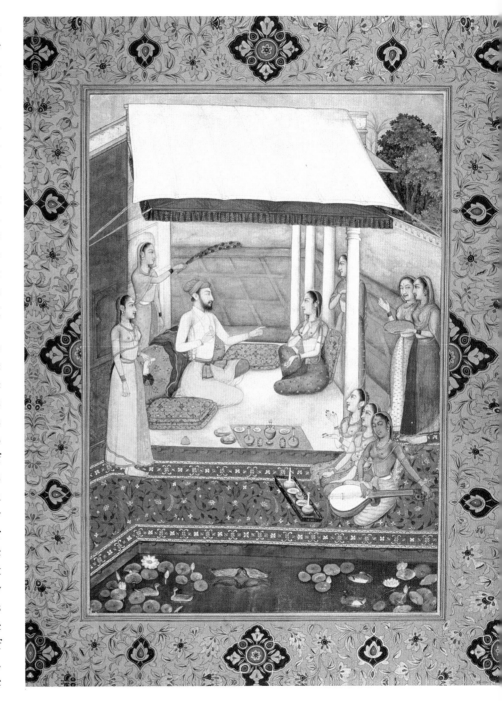

Facing Page

Village life in Kashmir. By Mir Kalan Khan. Avadh, c. 1760; 28.8 x 33.5 cms. British Library, Oriental and India Office Collections (Add. Or. 3). Mir Kalan Khan's earlier career at Delhi and Bijapur and his familiarity with an array of styles, Mughal, Deccani, Dutch and Flemish, enabled him to make re-cast of many masterpieces on popular demand. His mature style was initiated by many in Lucknow and Faizabad where he worked in comparative isolation. Persian inscription on the border of this painting reads: Majlis-i-Kashmir, amal-imir Kalan *(A Kashmir assembly, the work of Mir Kalan).*

vigour and charm of earlier phases. The emperor, who earned the sobriquet *Rangila* (Pleasure lover) perfectly exemplified 'a wilting imperial blossom.' A contemporary chronicle, *Mirat-i-Varidat* by Muhammad Shafi Tehrani, recorded, rather indignantly, how at the news of any incursion by the Maratha power His Majesty, 'with a view to soothing his heart afflicted by such sad news,' visited gardens 'to look at the newly planted and leafless trees' or 'rode out to the plains to hunt.' Blessed equally with a talent for pleasure, the grand vizier Qamaruddin Khan preferred 'gazing at the lotuses in some pools' to assuage his feelings. Muhammad Shah, who closed his eyes towards the unpleasant immediate reality retreated into the peace of his palace where he could patronize poetry, painting, music and dance. The surviving paintings, having a tranquil quality peculiar to the period, were produced both at the royal atelier and outside the court. The recurring compositions represented harem scenes, themes of love-making, courtly entertainments on terraces, the gathering of mystics and meditating ascetics and parade scenes. They seem to mirror the desire of the age to seek pleasure in the face of grave social and political crisis. A crisp palette abounding in white, shades of soft and silvery greys, browns, moss green, vermilion and ochre supplemented the smooth rhythmic drawing and profusion of surface detailing. Some of the

artists of Muhammad Shah were Chitarman, Govardhan Muhammad Faqirullah Khan, Honhar Hal, Mir Kalan Khan, Muhammad Afzal, Aqil Khan and Niddhamal.

Under the leadership of Nadir Shah, adventuring Persian freebooters took advantage of the crumbling administration and invaded the Mughal cities of Lahore and Delhi in 1739. Nadir Shah took back with him the famous diamond *Kohinoor*, the Peacock Throne of Shahjahan and many illustrated manuscripts including famed *Hamzanama,* stored in the royal treasury. The crumbling Mughal sovereignty and the precarious conditions prevailing in Delhi since 1739 quickened the dispersal of many artists mainly to the principalities of Avadh (Oudh) and Murshidabad.

During the late 18th and 19th centuries albums were assembled by both Indian and European connoisseurs and painters to some degree worked as 'copyist suppliers of pictures.' The painters, belonging to the Shah Alam II period adapted more and more to decorative conventions, which were manifested in a simplified scenic framework and tensed contours of the figures. The colours are marked by suppressed tonalities, much favoured during this phase. The idealized females with widened eyes and heavy greyish-brown shading on the cheek look poignantly wooden. Versions of Mughal miniatures belonging to the Akbar, Jahangir and Shahjahan period were

copied and re-interpreted. Even the original inscriptions or signatures of the masters of the earlier era were faithfully duplicated to deceive the collectors rather than to extend homage to them. The mounts *(vasli),* generously sprinkled with golden flowers, possibly with a view to recapture the richness of contemporary brocades, had an overwhelming impact on the central painting.

Designs *(naqqashi)* painted on the mount in gold or silver with addition of various colours was referred to as *kimkhab ki likhai,* the patterning based on brocaded designs with scrolls and creepers. Decorative designs inspired by the curls of the cloud was called *abr (abar) likhana.* The common term for big flower and leaf patterns was *buta,* for the bigger ones and *buti* for the smaller ones. Three-petalled

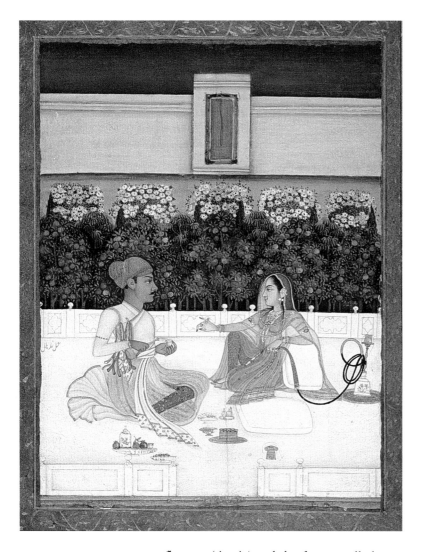

(joki: lit. 'leech motif') served as elaborate space-fillers. Derived from the repertoire of Persian painting, the classic mesh *(jal)* pattern was created with 'onion-shaped compartments' *(badrum)* each filled with a floral motif. Sprinkling the border with gold powder or gold leaf in fine particles *(ghubbara)* was much in vogue. The process was called *shafaq* or *afshan.*

A series of power struggles for succession made it easy for the East India Company to gain stable political ground. Mughal emperors, puppets in the hands of British Residents, were given a fixed sum as maintenance. 'Impressive brushwork' and 'overmodelled amorphous character' of figural and landscape forms were the two conspicuous elements of the early 19th century idiom. Incidentally, several *durbar* scenes of Akbar Shah II and Bahadur Shah II are perfect documents of the warring pageantry. Heavily loaded with golden flourishes, textile patterns, pearl and emerald jewellery, these scences show the 'twilight emperors' sitting motionless like icons with courtiers standing in perfect symmetry. Bahadur Shah II was identified by the British as chief of the insurgents of the Indian Mutiny (1857) and was exiled to Rangoon. The pathos of a dream unconquered is echoed in a *ghazal* he composed in these years under his pen name 'Zafar' (The Victorious):

My heart finds no love in a realm so desolate
Whose bride is found in a world so inconstant?

A navab with his mistress, by Niddhamal. Mughal, c. 1760; 19.3 x 15.2 cms. Bharat Kala Bhavan (No. 684).

flowers *(tipatia)* and the four-petalled one *(chaupatia)* were adjusted on the slender stem with petals *(pankhari)* and tendrils *(murri)*. Composing flower motifs at equal or parallel distances was described *chit likhana.* Floral meanders or scrolls *(bel)* was a common motif to fill the areas around the painting while interlaced leafy meander

From a long life's wish, but four days were granted:

Two were spent in desire, two elapsed in longing.

Say if you will:

 Live apart from this place of yearnings.

But where is there such space in a seared

 heart?

How star-crossed is Zafar, that for his grave.

He found not even two yards of ground

 in the lane of the Beloved.

 (tr. Brian Silver)

PROVINCIAL MUGHAL PAINTING

AVADH

~

In the delightfully ornamental style of Avadh (Faizabad and Lucknow) may be witnessed an enchanting afterglow of the Mughal idiom. The painters who migrated from c. 1750 onwards to Avadh with their sketches (*khaka*) and pounces (*charba*) succeeded in evolving a sumptuous technique of striking contrasts and exotic decoration. The specimens they produced between c. 1760 and c. 1800 were diverse off-shoots of the decadent Imperial trend. The movement of Delhi artists to Lucknow and other centres is affirmed by a letter (dated 1772) of a Maratha envoy in the Mughal capital addressed to Peshva Nana Farnavis:

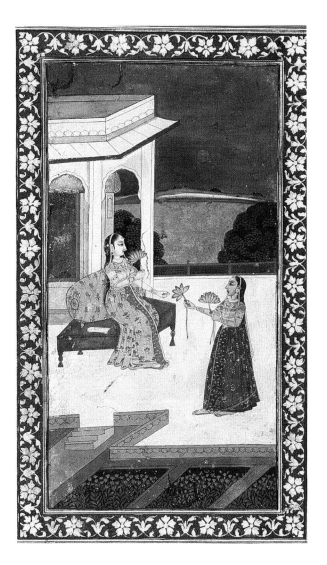

...There was a painter called Niddhamal, a devout Hindu ...After the unsettled conditions which followed Abdali's raid (1757), Niddhamal migrated to Lucknow, were he died. His two sons are in Lucknow; one is absolutely incompetent and the other is somewhat of a painter ...All the

The melody of late evening. Murshidabad, inscribed on the back: ragini Yamana, c. 1765; 22.8 x 14.2 cms. Bharat Kala Bhavan (No. 207).

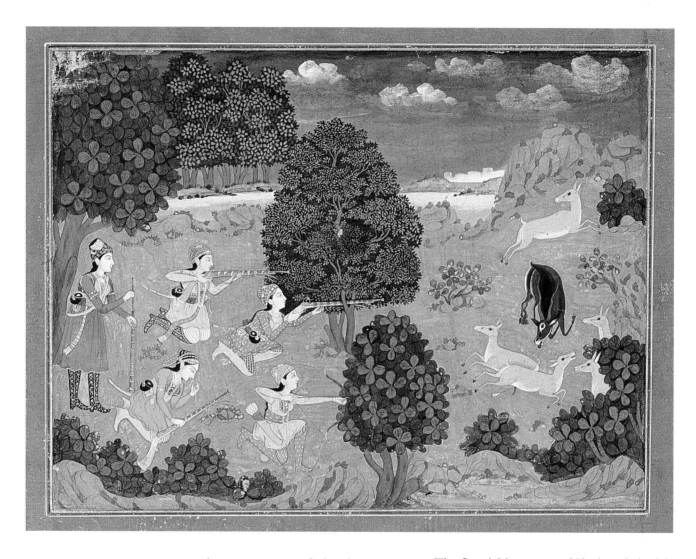

good artisans were out of job and starving and therefore migrated to Lucknow... Many died and their descendants are incompetent... Delhi is just the name left. There is no semblance of that Delhi which was there in the past...

(tr. A. Krishna)

The flourishing court of Shuja-ud-daulah (1754-75) and Asaf-ud-daulah (1775-97) attracted litterateurs and painters deserting the capital. Mihr Chand, who had a rare chance to see the two resident artists of the court namely, John Zoffany (active at Avadh, 1771-72) and Tilly Kettle (active at Avadh, 1783-89) work in the

European technique of oil on canvas, played a key role in this transitional phase. Among other artists who shaped the distinct idiom of Avadh were Mir Kalan Khan, Niddhamal, Nevasi Lal, Faizullah Khan, Bahadur Singh and Ghulam Reza. Kalan Khan's wildly evocative but pleasing experiments resulted from a combination of European, Persian, Mughal and Deccani traits. Signed works by Faizullah Khan present a wonderland of perspective with multistoried pavilions, terraces, water-courses, flower beds and distant city-scapes. Monotonous depictions of spectacular musical evenings in the walled gardens set against a beaming post-monsoon sky of red and golden clouds were produced for pleasure-seeking, profligate navabs. A generous use of pink, scarlet, acid-green and emerald (zehari) is hard to miss in such depictions.

MURSHIDABAD

~

The earliest surviving paintings typical of the Murshidabad style belong to the reign of Navab Alivardi Khan, which extended from 1740-56. Murshidabad, the administrative capital of Bengal and a flourishing commercial centre was famous for various qualities of silk and its cotton muslins of 'morning dew.' Following the victory at Plassey (1757) the British stronghold increased but it did not hinder the continuity of local art traditions of Hindu and Islamic inspiration. Court scenes, hunting episodes and *ragamala* series were commissioned by Alivardi, a person of 'sober and manly virtues.' A distinct draughtsmanly treatment enhanced by the entrancing combinations of white, grey and nocturnal blues are seen in these samples. The influence of itinerant painters from Delhi and Avadh is partly responsible for the changes occurring in Murshidabad painting by c. 1765. Conventionalized linear recession of buildings painted in white have all the incongruities of their late Mughal and Avadh archetypes. A certain greyish-brown wash given to enhance facial modelling replaced the time-consuming method of stippling, whereas the figures were drawn squatter and displayed restrained articulation. Miniscule detailing of the flower beds and fabric designs intensified the ornamental vigour of the paintings. The last quarter of the 18th century witnessed the emergence of a new clientele comprising English residents as well as visiting collectors with a deep-seated appetite for Indian picturesque. William Fullarton, a Scottish surgeon in Bengal and Bihar (during 1744-66) was one such enlightened patron. He preferred living in native style and commissioned Dip Chand and his fellow painters, who worked in a 'characteristically clear technique, with fine attention to sparse details,' for portraits of his friends and mistress.

Faces and Stances

~

The traditional Indian concept of portraiture was rooted in the curious process of internalization of the physical peculiarities to create an archetype, the metamorphosis of something radically immediate into an everlasting imagery. The painters of the Pala era continued with the frontal and three-quarter view of the faces they inherited from the classical wall paintings of Ajanta. Long-drawn, half-open eyes with drooping eyelids and arched brows were arranged in perfect symmetry along the centrally placed nose. The stylization of pinched nose-tip, jutting chin and extended further-eye at Ellora provided not only the inspiration for the painters of Jaina manuscripts but became an integral part of their idiom. The pre-Mughal traditions offer a range of facial types, as varied as other stylistic ingredients. One sub-style was marked by an unaltered continuity of the western Indian stylization for the faces. The other one, predominantly influenced by the 15th century Turkman idiom of Persian painting, displayed two standard facial types, namely, three-quarter profile and the strict profile. The painters of the *Chaurapanchashika* idiom refrained from affixing an extended eye to the face set in profile. Their spellbinding visual and emotive impact depended heavily on the wide-open staring eyes, with the pupil fixed at the centre, pointed nose and red lips. This freshly minted pattern was introduced to the repertoire of Akbari painting by the painters recruited from the pre-Mughal centres. The word *shabih* (likeness) was used by the Mughals for realistic portraits and *shabih lagana* for the art of portrait painting. A special section of Akbari painters confined themselves to the enrichment of the art of portraiture *(cheheranami),* both specific and imaginary. The three-quarter profile, a convention dear to the Safavid painters, became the stock in trade of the era while the strict profile was also becoming widely accepted. Jahangir and Shahjahan were fascinated with strict profiles, finished with care and objectivity. The late Mughal facial type in general became mannerized with standardized details and heavy shading.

The *Chaurapanchashika* facial idiom was again the archetypes for the early Rajasthani painting from Mevar and Bundi, while a notable Mughalization set in by the mid-17th century in the Bikaner school. Exaggerated to the maximum, the Kishangarh profiles consisted of a receding forehead, arched brows, eyes shaped like the lotus petal upturned towards the end almost touching the ear, sharp nose, thin lips and a well-modelled chin. The untamed vitality of Basohli portraits culminated in the expressive gestures of large almond-shaped eyes. The Guler-Kangra idiom was closer to the Mughal naturalism and the faces, inspite of being typified representations, conveyed every stage of the lyrical passion. Cast on Mughal patterns, Deccani portraits are rich in their dramatic impact. Frontal views recur in Company painting as a deliberate effort to imitate European models in thin gouache, with highlights precisely touched in white.

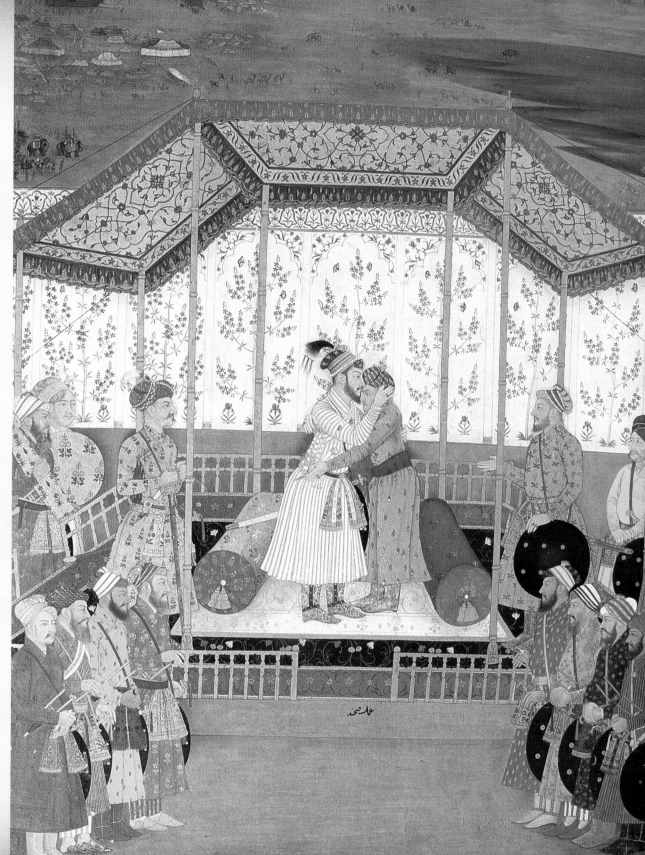

Prince Muradbaksh receiving Khusraw, son of Nazar Muhammad Khan, By Fateh Chand, Mughal, c. 1648; 34.9 x 24.1 cms. Bharat Kala Bhavan (No. 5403). In an enclosure created with floral kanats (tent panels or screens) under a brocaded canopy Prince Muradbaksh, the youngest son of Shahjahan, receives the envoy. The possible location of the encampment has been suggested as Sirab (Balkh). One may notice the use of court girdle by all the elite lined up on both the sides of the central platform. Such brocaded girdles or Sashes (patka) were decorated with flowering shrub motifs against gold or solid ground on the end parts, and floral meanders on the vertical borders.

A crowned Vajrayana *deity, Pala, c. 1100. Bharat Kala Bhavan. Notable feature: frontal face with half open eyes, arched brows and eloquent smile.*

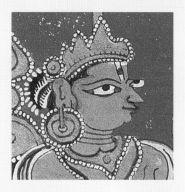

Indra, Western Indian, Mandu Kalpasutra, dated 1439. National Museum. The pointed nose, jutting chin and the extended further eye are here at their best.

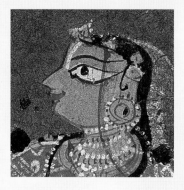

The cowherd woman, Pre-Mughal, Bhagavata Purana, c. 1550. Bharat Kala Bhavan. Notable feature: wide open staring eyes, pointed nose, red lips and a plump double chin.

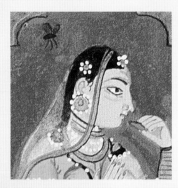

Radha at the window. By Sahibdin. Mevar, c. 1640. National Museum. Starkly angular profile with big startling eyes, based on the pre-Mughal Chaurapanchashika *idiom.*

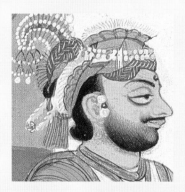

A Marvar prince. Jodhpur, dated 1725. National Museum. Expressive facial stance with exaggerated features. Minimum shading in tune with the flowing outline.

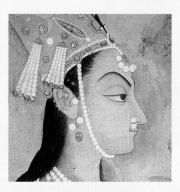

A Mughal Princess. Kishangarh idiom at Bikaner, c. 1760. Typical Kishangarh profile: receding forehead, pointed upturned eyes, sharp nose and a well-modelled chin.

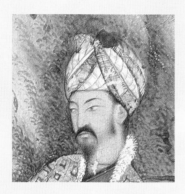

Babur. Mughal, Baburnama, c. 1597/98. National Museum. Classic three-quarter profile favoured by Akbar's studio. Noticeable Mongoloid stance with minute stippling.

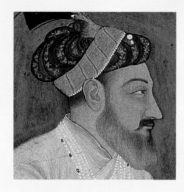

Shahjahan. Mughal, c. 1654. National Museum. A well grasped study with patiently observed details; gently modelled with tonal gradations and fine stippling.

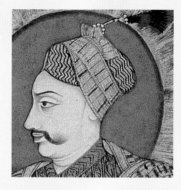

Abdullah Qutb Shah. Golconda, c. 1650. Bharat Kala Bhavan. Introduction of the Mughal idiom of strict profile with evocative detailing of facial features.

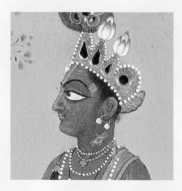

Krishna. Basohli, c. 1730. National Museum. Large avid eyes resembling lotus petals dominate the sharp-featured profile with pursed lips.

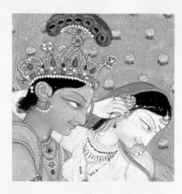

Radha and Krishna. By Sajnu. Kangra, c. 1815. Kangra idiom. Bharat Kala Bhavan. Faces of porcelain delicacy; eyebrow gently curving over long doe-eyes, the mouth small and hair in a thick mass.

Maharaja Ishvari Narain Singh. Banaras Company, c. 1865. Bharat Kala Bhavan. Painted in fluid strokes, a captivating frontal stance, a foreshortened nose highlighted with white.

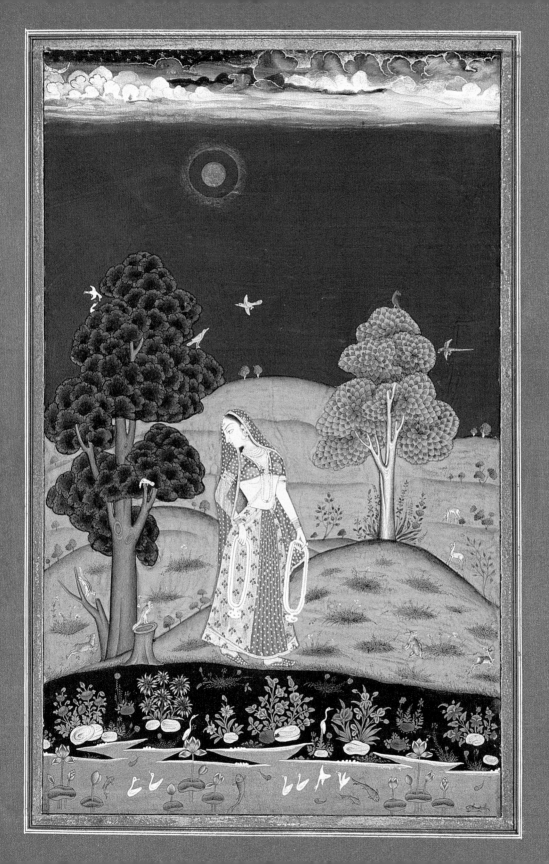

DECCANI PAINTING

The Deccan was ruled for two centuries by the five sub-sultanates of Berar, Bidar, Ahmadnagar, Bijapur and Golconda, which splintered as early as 1484 from the Bahmani kingdom. The Shia ruling dynasties united against Vijayanagara, the last Hindu Empire and won the decisive battle of Talikota in 1565. The conquerors absorbed many cultural traits of their Hindu enemies and recruited local craftsmen with sound background of medieval art styles of southern India. While no tradition of painting survived from Berar and Bidar, the three other Sultanates – Ahmadnagar, Bijapur and Golconda, became flourishing centres of Deccani painting.

Passing through phases of sudden maturation and prolonged stagnation, these schools of Deccani painting flourished in the 16th and 17th centuries but gradually withered away in the 18th and the 19th centuries. A multiracial society consisting of Indian Muslims, Hindus, Turks, Persians, Arabs and Africans shaped the contemporary pictorial idiom that has been likened to an 'impossible, fantastic mood of a mirage.' Pre-Mughal styles of painting as well as Persian, Turkish and even European traditions acted as catalysts to the flowering of miniature painting in the centres of Ahmadnagar, Bijapur, Golconda and Hyderabad. Compared to Mughal tradition of the 17th century, representation of historical events or ceremonies, portraits or thrilling hunting episodes in the schools of Deccan show a lesser concern for the factual. Finely controlled draughtsmanship and gorgeous harmony of hues were typical conventions followed by the Deccani masters. Conceived invariably as types, the human figures were rich in dramatic impact of gestures. Such a concept of stylization, lyrical yet sensuous, was closer to the Safavid mannerism of the 16th century.

Elements of fantasy pervaded even the landscape backgrounds. Painters with an extraordinary keenness arranged piles of rocks and clusters of foliage, sprinkled with blossoms of many hues. Shining bends of rivulets were edged with flowering shrubs and overhanging cloud patterns were touched copiously with gold and silver.

Very few of the surviving Deccani paintings bear the painter's signature, date or any inscription. Destruction and dispersal of the princely collections made the illustrated manuscripts as well as independent album paintings the 'rarest of the Indian schools today.' Akbar and Jahangir were greatly allured by the startlingly sensuous Deccani idiom, particularly that of Bijapur. Some of the masterpieces of the Deccan schools mounted with lavishly decorated borders (*hasiya*) have been located in the albums of Jahangir. A few Mughal painters of the early 17th century, in tune with their patrons' preference, were impelled to indulge in an 'exotic neo-Deccani style.'

AHMADNAGAR

Painting at Ahmadnagar flowered during the last few decades of the 16th century. Earliest examples, datable to c. 1565, are the twelve illustrations to *Tarif-i-Husain Shahi*, (The History of Husain Nizam Shan I). Husain Nizam Shah I (r. 1554-65) was the conquering hero of the battle of Talikota. The austere linearization, vibrant contrast and rich gold are reminiscent of the *Nimatnama* painted at Mandu. An eventual extension of the style seems to have embraced even northern Deccan as may be detected in a widely known but dispersed *Ragamala* set. Traced to c. 1590 the set was produced for a patron well-versed in Sanskrit. The figurative stylization, spatial organization and the aspects of landscape display a blend of the vigour of pre-Mughal *Chaurapanchashika* style and the lyricism of Persian painting from Bukhara. However, sophisticated painterliness of the next decade exemplified in several portraits of Sultan Murtaza Nizam Shah (r. 1565-88), have nothing in common with the style of the *Ragamala* or *Tarif*. The swaggering stances of the sitter were enhanced with subtle flattery and the effect of volume was added with painstakingly stippled shadows around the faces. To the last phase, from 1580 to 1590, belong a number of superbly executed line drawings *(siyah qalam)* strongly Persian in their calligraphic sweep and amplified linear rhythm.

BIJAPUR

A large number of the surviving Bijapur paintings make it easier to analyse the finer nuances of style and to appreciate its many

facets. Quite like Ahmadnagar, the late-16th century sporadic efforts at book illumination remained a separate genre that could never bleed into the succeeding phase. Ibrahim Adil Shah II (r. 1579/80-1627) was perhaps the most passionate connoisseur of Deccani painting, besides being a painter, calligrapher, skilled musician and poet. In 1601, with a little reluctance, he gave his daughter in marriage to Akbar's son, Daniyal. The valuable gifts sent to the Mughal court included illustrated volumes which were 'entirely the work of masters.' The opening decade of the 17th century thus created a congenial atmosphere for the cross fertilization of the Bijapur and the Mughal painting traditions. In this artistic synthesis, elements were received from Central Asian and Chinese sources via Persia as well as from European prints via the Portuguese. Ibrahim's poet laureate Zuhuri in his chronicle *Khan-i-Khalil* (The Table of the Friend of God) listed the names of the foremost calligraphers and painters of the atelier. The 'magical painter' Farrukh Husain, he claimed, 'was capable of putting in motion, the breeze which throws aside the veil from the face of the beautiful.' Sultan Ibrahim was portrayed by many contemporary artists, but for unknown reasons they preferred to remain anonymous. These portraits are undoubtedly the most poetic of the Deccani school with a background suggesting an ethereal magnificence.

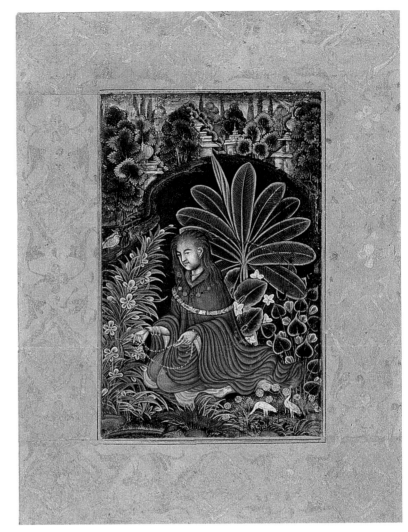

Painted in early 17th century a number of enigmatic figures of *Yogini* (a female mendicant), enveloped in a certain otherworldly landscape, evoke a mood of dizzying melancholy. An increasing Mughalization of the Bijapur school after c. 1630 may be credited to the Mughals who were stationed in Deccan,

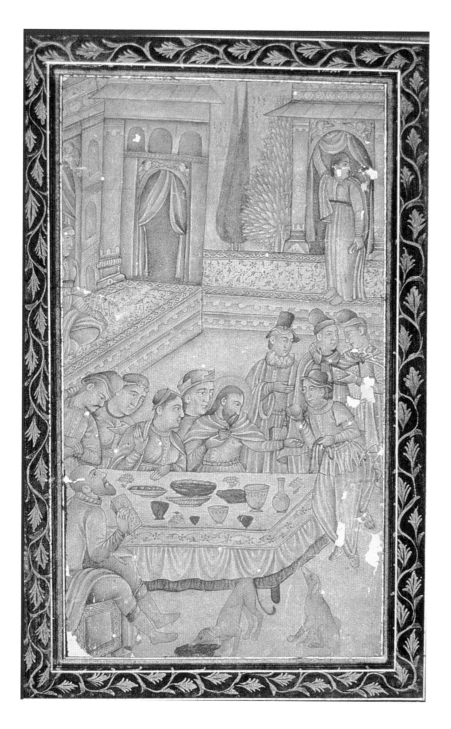

accompanied by poets, painters and musicians besides the administrative staff. Some of the portraits of Muhammad Adil Shah (r. 1627-56) are notable for an air of grandeur and courtly pomp, a characteristic of the royal portraits of Shahjahan period. However, this shift from idealized types to heightened naturalistic details was short-lived. Ironically, the Mughalized painterliness reverted back to the earlier lyricism which conveyed a sense of unbridled fantasy.

GOLCONDA

Founded in 1512, the Qutb Shahi dynasty of Golconda was rooted in the cultural patterns of 15th century Turkman Persia. They extended patronage to Persian painters who carried with them the master drawings, pigments and other necessary 'tools of their trade.' The influences of Safavid, Mughal and Bijapur traditions operated simultaneously and went into the making of the Golconda idiom. Possibly due to this, a large number of the examples have been seen as 'isolated peaks of achievement, bearing little stylistic relation to each other.' Illustrated *Kulliyat* (Collection) datable to c. 1600 of Muhammad Quli Qutb Shah's (1580-1612) Urdu poetry represents the early phase, considerably overshadowed by the ornamental vivacity of the Bukhara school.

Large compositions belonging to a slightly later date, are visual representations of the poetic metaphor abundant in contemporary Deccani literature. Abdullah Qutb Shah (1626-72), emerged as an inspired patron, though his political power was curbed and Golconda was transformed into a Mughal protectorate in 1635.

A sudden degeneration of the local style was inevitable after the destruction of the royal collection by Aurangzeb in 1687. Inspite of that, painters went under private patronage and produced quite a body of charming paintings. The Maharajas of Bikaner who were posted in Deccan for long years acquired paintings from Bijapur and Golconda. Some of the painters accompanied their Rajput patrons and on returning, experimented with the freshly-acquired prototypes for the human figures and scenic settings. A possible reason behind the sudden surfacing of Deccani traits in the Rajasthani schools of Bikaner, Kota, Mevar and Jodhpur,could be the migration of the Golconda painters.

its new capital Hyderabad in 1724. Miniature painting developing in the 18th and 19th century became increasingly repetitive and started moving within a set range of cliches. The Nizams were undoubtedly the foremost patrons; however, equally keen were the nobles of the court, both Hindu and Muslim. Curiously, the art of portraiture took a different track, becoming wooden and at times comical. The numerous sets of *Ragamala* produced for unknown bibliophiles and lovers of music display a high degree of perfection. Somewhat liberally elongated slender female forms are invariably the central figures of the composition, personifying the *ragini* (melody). A landscape effect is achieved by the grouping of attenuated trees amidst oblong and bulky rock clusters rising unhindered above the jagged shore of a lake in the foreground. Framed with softly modelled clouds, the effect of cool moonlit-nights often lends a special charm to the visualization of a certain melodic mode.

HYDERABAD

~

Nizam al Mulk 'Asaf Jah' I (r. 1724-48), an able administrator, dissatisfied with the onset of political anarchy in Mughal empire, founded the Asafiya dynasty with

73

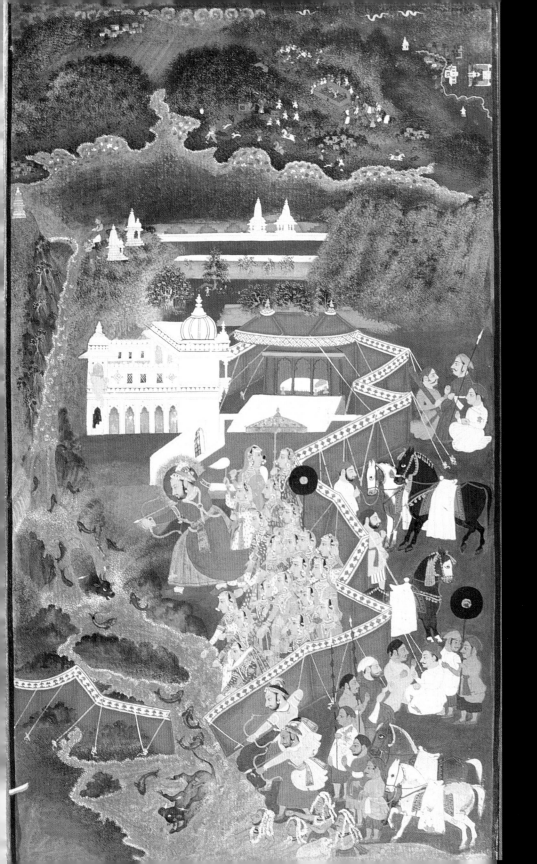

RAJASTHANI PAINTING

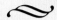

Several schools of miniature painting flourished between the early 17th and 19th centuries in various principalities of Rajasthan. Inheriting diverse traditions, they displayed a rich range of expression. Mevar, Bundi, Kota, Jaipur and Kishangarh in eastern Rajasthan and Jodhpur, Bikaner and Jaisalmer in the western region became the important centres of painting. Artists or *chiteras* moved from one Rajput principality to the other. Illustrated manuscripts were often exchanged as marriage gifts, or formed precious items of dowry. This led to a beautiful fusion of painting styles from various centres of Rajasthan.

The Rajputs belonged to the warrior class and claimed descent from Rama, the hero of the epic *Ramayana*. Their heroism on the battlefield was immortalized by bards. Mass self-immolation *(jauhar)* by the women, to avoid the enemy's humiliation, was held sacred. Divided by internal conflicts, the Rajputs failed to stem the unhindered inflow of Islamic conquerors from the 10th century onwards. Rajput insurgence was shattered by Babur in 1527, when Maharana Sanga of Mevar was killed in battle.

It was Raja Bhar Mall, head of the Kachhwaha clan of Amber (later Jaipur), who set up the precedent of matrimonial alliances with the Mughals. He gave his daughter in marriage to Akbar as early as 1562. Other Rajput chiefs followed suit. Some of them joined the imperial elite as generals or high ranking administrators and fought loyally in the Mughal campaigns in Bengal, Bihar, Deccan and Afghanistan. During their long stay at the Mughal capital, they absorbed substantially the court ethos and also adopted the fineries of costume. Over time, many of these chiefs became patrons of architecture, music and painting. The Rajput patrons often commissioned painters who had left the imperial Mughal

studio being unable to measure up to its high standards. What was growing antithetical to the emergent Mughal naturalistic diction became a contributing factor in the making of Rajasthani tradition. Investigating the natural world, by studying its intricate details, could never become the sole purpose of Rajasthani

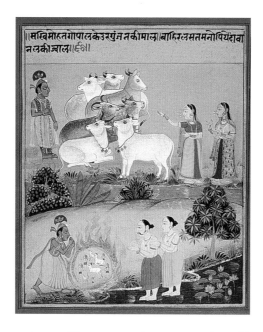

painters. They reverted to types and motifs discarding 'the vividness of the immediate effect.' Elements of the distinctive landscape were often presented, subject to vigorous stylization. Each school worked out a special facial type, invariably a profile. Traditional Rajasthani costumes and elaborate headgear, made of dyed or woven fabrics, were seen in vibrant primary colours. In the earlier style at Mevar and

Bundi, the two-dimensional effect was enhanced by the intensified chromatic value of pigment.

Apart from the Mughal and Deccani elements, the strong link between the aristocratic and folk arts of Rajasthan cannot be ruled out. Re-configuration of the Mughalized iconography for portrait was at times delightfully sensuous yet quintessentially non-naturalistic. The differences between the Mughal and Rajput painterly approaches, were critically summed up by Ananda Coomaraswamy, who is justly credited with the discovery of 'Rajput Painting':

Apart from the illustration of manuscripts, in direct continuation of Persian tradition, Mughal painting is essentially an art of miniature painting, and when enlarged, becomes an easel picture ... Rajput painting enlarged becomes a mural fresco, historically, indeed, is a reduced wall painting. Mughal painting uses soft tonalities and atmospheric effects; Rajput colour suggests enamel or stained glass, and while it may be used to establish the planes, is never blended to produce effects. Mughal outline is precise and patient, Rajput interrupted and allusive or fluent and definitive, but always swift and facile. Relief effect is sought and obtained in Mughal painting by means of shading and Rembrandt-like *chiaroscuro* is often introduced; Rajput colour is always flat and a night scene is lighted as evenly as

one in full sunlight, the conditions being indicated by accessories (such as candles or torches), rather than represented.

(*History of Indian and Indonesian Art,* p. 128)

Painted scrolls (*phad*) used by picture showmen represent a vital folk tradition present alongside the courtly tradition. Interiors of the Rajput palaces were invariably painted and very often the themes and even the composition of the miniature paintings were duplicated on the wall with very little structural alteration.

Religious and secular literary sources provided the Rajasthani painters with sources of inspiration. Episodes from Hindu *puranas* (collections of ancient tales) and the two celebrated epics, *Mahabharata* and *Ramayana* were taken up. The *Bhagavata Purana,* projected the cardinal cult-beliefs of medieval Vaishnavism. It detailed the legend, glorifying the incarnation of Vishnu as Krishna. The first half of the Tenth Book of the *Bhagavata,* focuses on his childhood deeds and his romances. The *Rasapanchadhyaya* lifts the entire myth to a new height concentrating on the dances and the dalliance of Krishna, 'the lord of the autumn moons.' The *Devi Mahatmya*, or the Glorification of the Great Goddess, was also a popular text for illustration. Her many deeds, including the fight against the evil, were rendered with perfect iconic details.

Another persistent genre was *shringara,* originating in Sanskrit texts on poetics and becoming increasingly popular and a little mannered in medieval Hindi literature. The *shringara* literature aimed at typecasting heroes and heroines *(nayaka-nayika bheda)* and defining a variety of possible emotional states in the

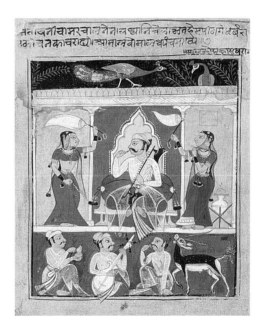

movements of love. A passage from Coomaraswamy's chapter on *shringara* from his 1916 classic *Rajput Painting,* lucidly explains the essence of the painted allegory:

Rarely has any other art combined so little fear with so much tenderness, so much delight with such complete renunciation. If the Chinese have taught us best how

Raga Malkaus. Mevar, Chavand Ragamala *series, 1605; 20.8 x 18.1 cms. Bharat Kala Bhavan (No. 10666).*

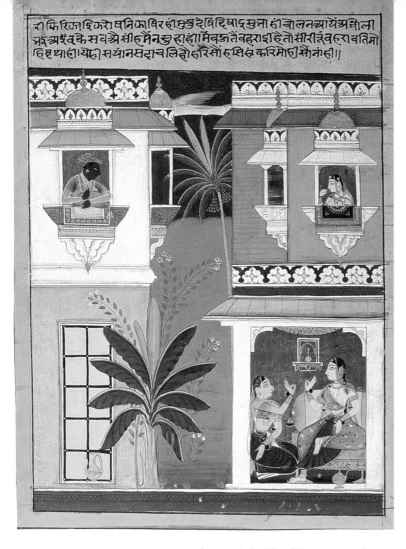

राकिरिकाधिकराधनिकाविरहाउकुटदरविरिषादसुना हांचालनव्यायेंअनीला
जधअश्वकसवच्छेसीलमैनछुराहामेवक्तैवहराशिहेतोसोरारंवररावतिमो
हिरथाधायेधासयानसराचलिततोहरिसोंहप्तिहकरिमोहासौनोंहो।।

*Krishna and Radha
exchange glances. By
Sahibdin. Mevar,
Rasikapriya series, c.
1630-35; 27.2 x 20.8
cms. National Museum
(No. 57.68:2).*

to understand the life of Nature manifest in water and in mountains, Indian art at least can teach us how not to misunderstand desire, for we are constantly reminded here, that soul of sweet delight can never be defiled ...the more one follows this impassioned art, the more is it clear that its complete avoidance of sentimentality, the certainty of its universal appeal, are founded in its constant reference to the physical fact. The abstract and the spiritual are constantly proved by reference to the concrete and material, as is only possible where it is believed that all is intertwined...

(*Rajput Painting*, p. 42)

Other closely related themes were the *barahmasa* and the *ragamala*. The *barahmasa* tells of the changes in season over twelve months and how they affected lovers' attitudes. In the *ragamala,* musical modes are illustrated according to specified iconographic rules. The sentiments of blissful union or unceasing languish expressed in *shringara* literature were often combined in such portrayals. Popular love ballads namely, *Dhola-Maru, Sohni-Mahivala, Madhavanala-Kamakandala, Nala-Damyanti, Hammira-hatha, Laila-Majnu,* etc., provided themes which were frequently taken up by the painters. The narrative passages to match the visuals were inscribed on the border or on the reverse side. However, a rigid dependence on textual details eventually resulted in mechanical illustrations with the persisting cliches.

Inscriptions on the early paintings are cryptic. Some of the 18th or 19th century large-sized paintings from Kota and Udaipur, however, carry every single name of the person portrayed, with the artist's name being written in most cases by the clerks. Recent archival accounts *(bahis)* have proved a veritable treasure-trove of information regarding the patronage,

painter's status and his parentage. The nature and cost of the art materials used in the royal studio and artists' outstanding creations were also listed. Copies or *nakal* of the original were also made under the guidance of master painters *(ustads)*. Alongside, other routine activities of the workshop continued, namely, correction *(gudarayi)* and repair *(marammat)*.

MEVAR

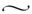

The rulers of the region traced their lineage to 'The Great Clan of the Sun' and bore the title *Rana*. Till A.D. 1606, the descendants of Rana Sanga were unwilling to accept Mughal hegemony. Akbar besieged the massive fortress at Ranthambore but Rana Pratap Singh (r. 1572-97) who managed to escape, refused to surrender. Maharana Amar Singh (r. 1597-1620) yielded to Jahangir in 1614. Rana and his son, Karana Singh, both were warmly received by Prince Khurram who showered gifts on them including the *khilat* (robes of honour), horses, jewelled daggers and royal elephants.

The earliest dated example of the Mevar style is a *Ragamala* painted in A.D. 1605 at the temporary capital, Chavand, by Nisardin Nasiruddin chitera *(painter)*. Trained in the Mughal atelier, he probably moved to Rana's court and worked out the basic elements of the Mevar style. The

Ragamala paintings displayed a blend of the pre-Mughal *Chaurapanchashika* idiom and certain simplified mannerisms of the popular Mughal creations. The faces in profile were softer, while the iconography still retained the pre-Mughal dynamism. The architecture was more like a motif and the landscape was highly suggestive.

Ragini Sarang. *By Sahibdin. Mevar, dated c. 1628, 25 x 17.9 cms. Bharat Kala Bhavan (No. 10667).*

Maharana Karana Singh (r. 1620-28) was open to Mughal cultural influences and under the patronage of his son Maharana Jagat Singh I (r. 1628-52) the art of manuscript painting witnessed a revival. Sahibdin (c. 1620-55), like Nisardin, was well-versed in the Mughal style. He sought employment initially under Jagat Singh but continued to work for his successor Raj Singh I (r. 1652-80) for some years. Sahibdin's earliest *Ragamala* illustrations (15 July 1628), painted at Udaipur, show more positively detailed pictorial elements though the vibrant palette is reminiscent of the Chavand *Ragamala*. Manuscript illustrations highlight his distinguished career of almost thirty years. His style which became the model for the rest of the 17th century and beyond included monoscenic compositions divided into units, high view point, the diagonally flowing river with aquatic creatures, the variety of stylized trees and lavish use of flowering creepers. The orange trees appearing frequently seem to have been inspired by the flowering *gulmohar* trees found abundantly in the Aravali range.

Raj Singh became a symbol of resistance against the religious bigotry of Aurangzeb. It was during his reign that the celebrated image of Sri Nathji was shifted in 1671 from Mathura to Nathadvara which became the centre of a Krishna cult propounded by Vallabhacharya. The painted temple-hangings *(pichhavai)* from Nathadvara evoke visions of a divine magnificence.

Inspired by the contemporary models of Bundi, the earliest royal portraits and depictions of court life were painted during the reign of Raj Singh I (r. 1652-80) and Jai Singh (r. 1680-98). Painters became 'detachedly but comprehensively observant' of the conventional yet formal happenings at court and the pleasant recreation pursued by the rulers in their private apartments. Enlargement of the picture format was a notable feature that continued in Amar Singh II era (c. 1698-1710). He emerged early as an active patron of painting while holding a separate court as prince.

Under Rana Sangram Singh II (1710-34) Udaipur painting took a new direction. The subject matter was no longer confined to illustrations of myths and poetry. Hunting scenes, festival celebrations or royal visits to holy men were included besides court scenes. However, such densely-peopled panoramic compositions gradually lost their 'solemnly documentary atmosphere' and took on an air of escapist gaiety during the reign of Jagat Singh II (r. 1734-51). Blessed with a rare 'determination to be happy amidst calamity,' he extended generous patronage to the arts and re-invented many festive celebrations. Inscriptions on the paintings reveal that usually two or three painters were allowed to work collectively on a large composition. Pyara and Naga, Syaji and

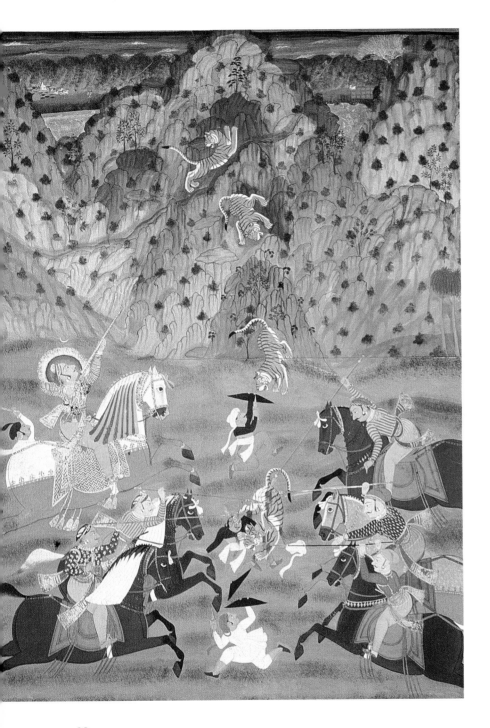

Sukha as also Bhima and Kesu Ram were among the artist pairs who collaborated to produce such large works for Jagat Singh. Many of the talented artists left Udaipur by the end of the unpopular Ari Singh's (r. 1761-73) reign and a few joined the northern fiefdom of Deogarh.

A period of steady decline ushered in by the mid-18th century. Numerous stereotyped portraits with monotonous reliance on flat backgrounds and large-format hunting scenes are the best representatives of this phase.

Those painted for Maharana Javan Singh (r. 1828-38) were expressedly mechanical. Tiny figures were detailed and at times placed oddly in an incongruous perspective. Some of the elaborate hunting scenes were certainly drawn from a mental image of the hunting ground *(rumna or shikargarh)*. They were finished in the studio relying more on the memory of the locale than on sketches done on spot. Given the episodic continuity of the event, the compositional units were turned into an uncontrolled mode of linear progression. An interesting textural effect was obtained by dabbing some parts of the rocky expanses and vegetation with a cloth pad soaked in colour. Eventually, the trees looked more like identical daubs. The architectural design lost its earlier close-up intensity.

From the mid-19th century Udaipur painters came under the influence of the European technique which depicted

expanding views and lifelike portraits. One cannot appreciate the painterly assimilation of the 'view-points' and the ideals of precision in the contemporary painting without bearing in mind the fact that most of the modern Maharajas were familiar with the art of photography.

BUNDI-KOTA
~

Bundi and Kota in south-eastern Rajasthan, formed a unified state till A.D. 1624. It was ruled by two different branches of the Hara clan. The early history of Bundi or Vrindavati as it was known initially, is evident from the panegyrical accounts of ballads. Surjan Singh (r. 1554-85) of Bundi served the Mughals from 1569 and was bestowed the title Rao Raja. The Chunar district near Banaras, was also granted to him.

The earliest document which displays the emergence of a distinct Bundi idiom is a *ragamala* painted at Chunar in A.D. 1591 by Shaikh Hasan, Shaikh Ali and Shaikh Hatim, pupils of Mir Sayyid Ali and Khavaja Abd us-Samad.

The Persian incription on the verso of a folio from this *ragamala* is as follows:

He is God – may he be exalted!

The book *Rag-mala* was ready (on) the day of Wednesday

At the time of the mid-day prayer, in the place of Chunar, the work of the pupils Of Mir Sayyid Ali Nadir ul Mulk Humayunshahi, and Khvaja Abdus Samad

Shirin Qalam, the slave Shaykh Hasan and Shaykh Ali and Shaykh Hatim (?) son of Shaykh Phul Chishti; written on the date of the 29th of the month Rabi'u'l Akhir, year 999 (c. A.D. 1591)
Written by the slave
Da'ud son of Sayyid Jiv.

(tr. Simon Digby)

The painters, trained under the master artists of the Mughal atelier, derived the figural and landscape elements from the popular Mughal style to be carried over and reinterpreted again at Bundi and Kota. The vertical format of the folios and the border decoration with arabesques and cartouches are indeed such Mughal features. The lush vegetation and the architectural details enlivened by the tile-work are also to be noted. Typical also are the plump profiles of faces with pronouncedly modelled cheeks.

Painting during the second half of the 17th century was marked by a lyricism with the maximum surface being animated. The background was copiously filled with varieties of blossoming trees, illustrating the abundance of nature. The palette became brighter with luxurious juxtaposition of intense chromatic nuances.

Detail Maharana Ari Singh's tiger hunt. Mevar, c. 1740. Private Collection.

Facing Page

Maharana Ari Singh's tiger hunt. Mevar, c. 1740. Private Collection.

Maharao Kishore Singh (r. 1819-27) of Kota participating in the Vijayadashmi celebration with the burning of the effigies of Ravana and other demons. Kota, c. 1825; 51.2 x 44.5 cms. S.S. Backliwala Collection. Following an armed conflict with the Regent's army, Maharao Kishore Singh ceded all power to the British government in 1821. In light of Maharao's numerous depictions in murals and miniature paintings as a pious man, it is hard to rationalize the heroic aspect of his personality, and his determination to fight against the British army with sustaining courage. Here he appears seated on an open palki *wearing a white* jama *(tunic) and a turban 'tied in his favourite, easily distinguishable style.' Encircled with a green nimbus his portrait emits a royal grandeur, unaffected by the hustle-bustle of the surrounding area teeming with jubilant participants. Attempts to control an enraged elephant is a predominant happening while the* joie de vivre *of a group of playful monkeys in a camp allows a lighter strain to drift in.*

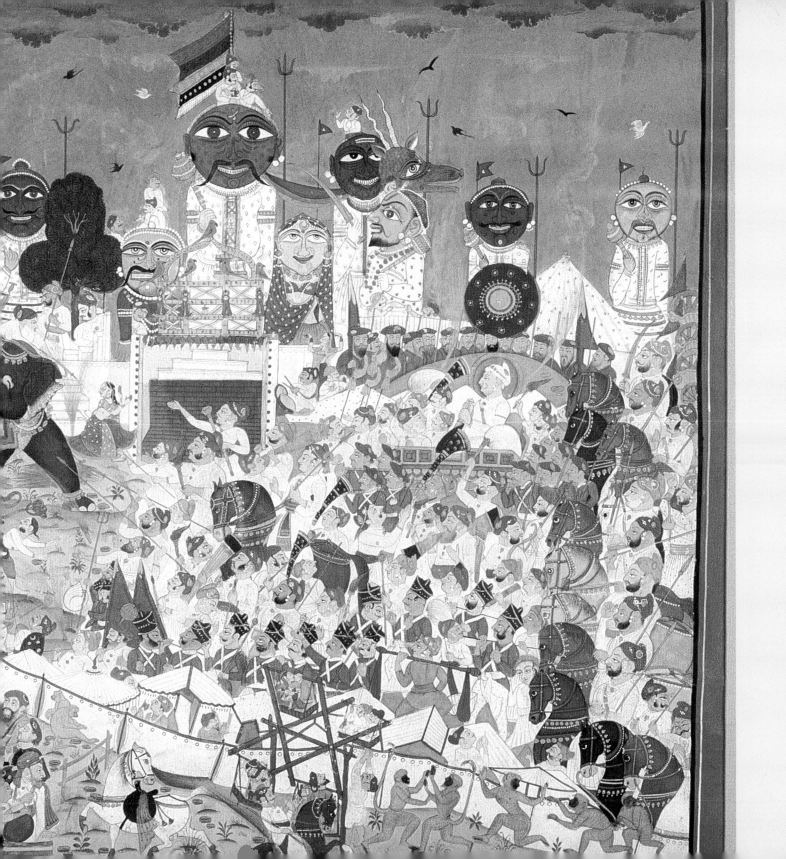

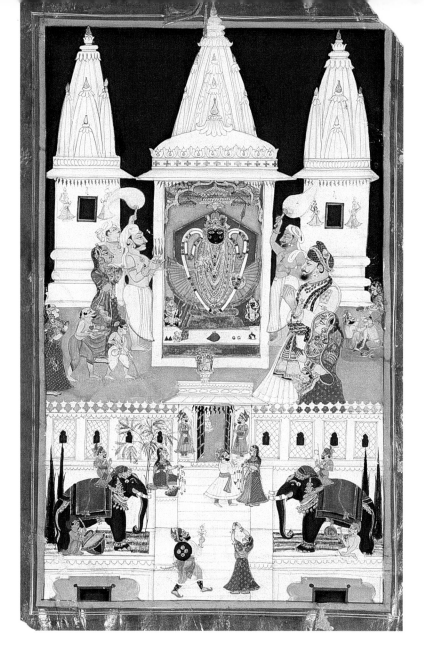

of the pleasures in the harem garden are lyrical in their treatment of trees and beds of flowering shrubs. A *ragamala* series was painted in c. 1690 based on the classic Chunar *ragamala* set. The compositions became simpler and the vegetation was suggested with hurriedly touched strokes. The flesh tint lacked functional modelling and even the interior furnishings as well as architectural decoration underwent changes. These copies reflected the painter's intention to update the subsidiary details, besides being a reference to an important *ragamala* set. A definite link between the past and present was thus created.

Absence of dated material, however, makes it difficult to pinpoint the style of 18th century Bundi painting that depended more and more on sombre colour harmonies.

Emperor Shahjahan divided the Bundi state in A.D. 1731 and handed over the southern part, Kota, to Rao Madho Singh as a token of appreciation for his bravery in suppressing the rebellion of Khan Jahan Lodi. Much of the early painting at Kota followed the Bundi prototype with minor variations. During the 18th century, a new facial type, with rounded forehead and smoothly stippled shading became popular. Painters who accompanied their patrons in hunting expeditions had a chance to observe animal life closely. The backgrounds of the large-scale hunting scenes, depicting

From works which are dated and can be attributed, it is firmly established that Bhao Singh (r. 1659-82), who spent long years in the Deccan at Aurangabad, was an ardent patron of painting. Based on Mughal sources, some of the depictions

the *rumnas* (hunting preserves), were conceived to commemorate the thrill of these events.

The earliest Kota hunting scenes belong to Rao Ram Singh's (r. 1696-1707) reign and from Maharao Durjan Sal's (r. 1723-56) reign they became increasingly popular. Umed Singh I (r. 1770-1819), an avid hunter and a renowned shot of his times, extended patronage and rewarded his court painters for documenting vivid incidents of hunt. The thick jungles along the banks of the river Chambal, were infested with wild beasts. Beaters used to drive the game from the heart of the forest towards the shooting boxes *(mul)* or tree-hideouts *(machan)* already occupied by the royal hunting party. Kota rulers accompanied by their huntsmen *(shikaris)* often cruised along the banks in barges shooting wild animals. Several *khakas* or preparatory line drawings attest to the prevalence of this practice. The long reign of Umed Singh was followed by the precarious political interlude of Maharao Kishore Singh's (r. 1819-27) rule. Inspite of mediation by the British political agent, the conflict between Maharao and the *divan* (minister) Rajrana Zalim Singh continued. Maharao went into exile, and stayed at the shrine of Shri Nathji in Nathadvara. Some of the large-sized paintings inspired by the contemporary festivals or visits to the holy shrine may have been painted by the *chiteras* (painters) accompanying the patron in exile.

In the reign of Kishore Singh's nephew Maharao Ram Singh II (r. 1827-66) Kota painting entered a phase marked by the consolidation of the earliest stylistic traits and the formation of an idiom intensifying the drama of visual reality. No other Kota

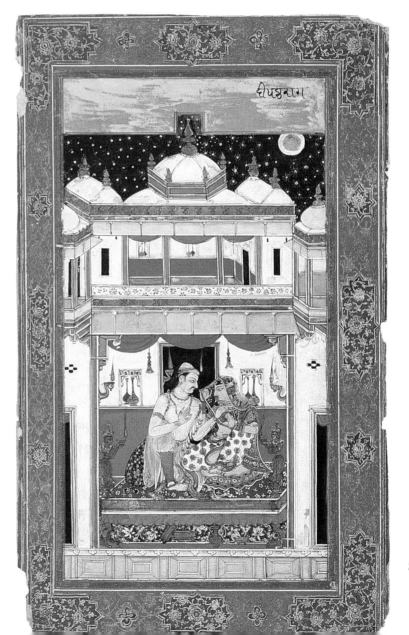

Raga Dipika, *Chunar Ragamala series, Bundi, 1591, 25.7 x 15.9 cms. Bharat Kala Bhavan (No. 5444).*

87

ruler's daily routine was so vividly documented. Numerous paintings and drawings centred around energetic rhythms of hunting and chase, courtly ceremonies, festivities or scenes of worship with Ram Singh as the principal character. Some of the hunting scenes immortalize the participation of ladies in this male-dominated sport. An inscription in the palace at Dara is a lively document of the celebrations and bestowal of rewards that followed a successful lion hunt in A.D. 1849:

Shri Hari
Hail, hail to the Lord of Vraja (Krishna);
An allusion to the golden idol of Shri Brijnathji who assumed the supreme position in the pantheon at Kotah and at times was represented by hunting animals dressed in *moongia ghooghis* or green-coloured camouflage gowns.

Obeisance to the Fortunate and Great, the Lord of the Ganas (Ganesh). Hail to Him, the elephant-headed (God), meditation on whose lotus feet leads to the removal of all obstructions even as the sun destroys darkness.

May there be Good Fortune, Shri Shri Shri, the Lord of the Earth, Maharaja, the King of Kings, the King among Kings, Maharaja, Maharajaji, Shri Ram Singhji. Samvat 1906 (c. 1849 A.D.), the fifth of the dark half of the month of Pausa. The village of Nanda,

Kota ... a lion was shot. The lion was beaten out of his lair and shot from the shooting parapet. The same day, a great thanksgiving feast was held in the palace at Dara. The army was treated generously to delicacies like *sira, puri, khir* (a rice pudding), etc. The elephants, horses and bullocks were also treated to *khir* ... there was a musical *soirée* in celebration in which Bhagtanyya Kalwant (a dancing girl) performed. Rewards were given and general festivities organized. (The Maharaja) entered Nandgaon (lit. 'the village of Krishna's foster father Nanda'; the name given by Bhim Singh to the Kota state in 1719) on horseback the same day... *Doshalas* (shawls) were distributed among the nobles. *Siropas* (robes of honour consisting of headdress, a sash, a material for tunic and breeches) and cash were also distributed. Afterwards, he (the Maharaja) entered the palace and met Gracious lady (the Rani). In the town there was a rain of coins. Festivities went on... May there be prosperity and well-being.

(tr. Dr. B.N. Goswamy)

An inscription on the back of an exquisite hunting scene dated 1781 mentions that a sum of Rs. 4,000, a horse and five pairs of gold bangles were given to *chitera* Akheyram by Umed Singh I in appreciation of his painterly skill. There is yet another contemporary record of an award comprising Rs. 1,000, a pair of gold

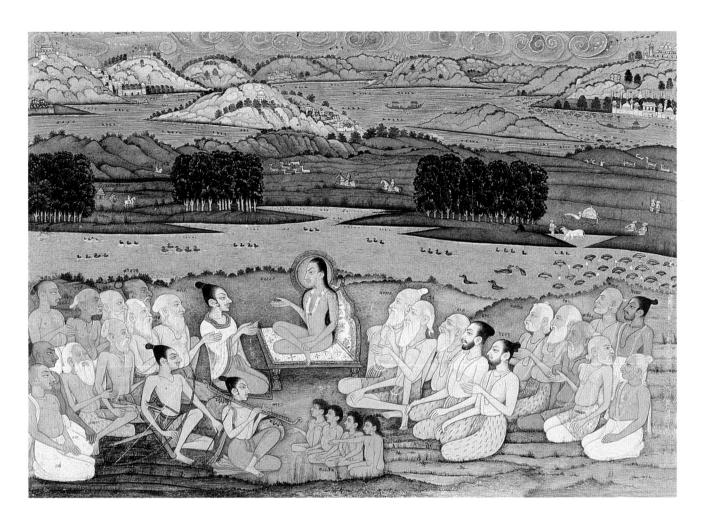

bangles and a set of *siropa* which was given to *musavvir* Chorpal for a graphic depiction of a tiger hunt.

The shift from the plastic to a predominantly draughtsmanly handling in the 19th century is often linked with the gradual dismissal of artists trained in the Mughal technique. Later history is marked by chaos and ineffective administration which led to sub-division of the state. This in turn created a certain complacency in the attitudes of the patrons.

KISHANGARH

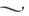

Kishan Singh (r. 1609-15), a Jodhpur prince, founded the state in 1609 and built

The Sage Sukadeva addressing King Parikshit. Kishangarh. c. 1760, 32 x 22 cms. Victoria and Albert Museum (No. IS. 556-1952).

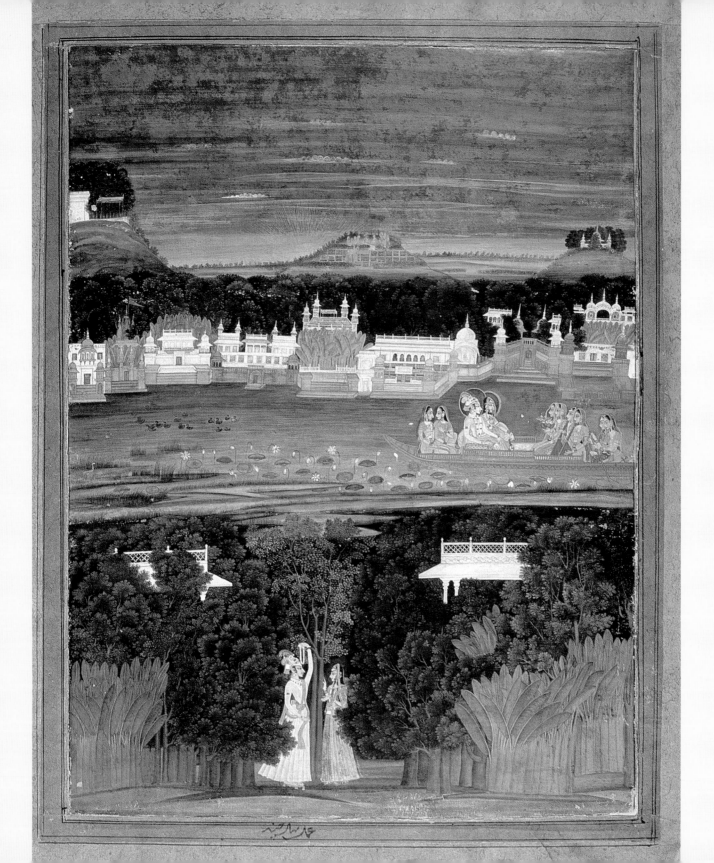

the fortress near the Gundalao lake, which features so often in the Kishangarh paintings. In the centre of the lake is a white pavilion accessible only by boat. Filled with rain water and overgrown with lotuses it attracts herons, egrets and ducks. This territory, lying between Jaipur and Amber, prospered in the 17th and 18th centuries. Raja Raj Singh (r. 1706-48) and his son Raja Savant Singh (r. 1748-57) both extended patronage to painters fleeing from the imperial atelier. They were both followers of Vallabhacharya's *Pushti-Marga* or The Way of Grace. This denomination of Vaishnavaism combined a sound metaphysical basis with an emotional expression of ritual worship to Krishna in a deified form. Savant Singh adopted the *nom de plume* Nagari Dasa and started writing verse in praise of Krishna and Radha. Three of his major collections of verses namely, *Manoratha Manjari, Rasika Ratnavali* and *Bihari Chandrika* were composed between c. 1723-54. Apart from their dominant religious note, a few of his poetic creations deal with the special features of the seasons and which are connected closely to the temple rituals. The poems were especially meant to be sung during particular temple ceremonies. He fell in love with Banithani, a talented singer in his stepmother's employ. She also wrote poetry in *Brajabhasa* under the pen name Rasikabihari and worshipped and sang in praise of Krishna, dark as a raincloud. Bitter fratricidal strife,

following his father's death, led Savant Singh to give up his throne, and to spend the rest of his life at Vrindavana. Savant Singh was himself a painter and singularly fortunate in having the extraordinarily gifted Surdhaj Nihal Chand heading his atelier.

Unlike Mevar and Bundi, the Kishangarh school never underwent the gradual process of maturation, starting from the popular Mughal inspiration. The elongated, figurative stylization of the late Aurangzeb period and the lyrically mannered idiom of the Muhammad Shah era provided the basic patterns which were modified according to the thematic requirements of Nagari Dasa's poetry.

The earliest dated portrait of Savant Singh belongs to A.D. 1745 when he was still the crown prince. Painted in the twenty-fifth regnal year of Muhammad Shah, this standing portrait in profile is a typical late Mughal composition comprising terrace, lake and distant rocky landscape. A golden nimbus surrounds the face while the body is elongated. Also discernible are some characteristics of the Kishangarh formula for faces in early stages.

Not all the paintings of the *Krishna-lila* theme painted afterwards were explicit illustrations of narrative situations culled from the *Bhagavat Purana*. The very concept of Krishna was no more of the pastoral God, the divine cowherd who vanquished so many demons but of a

prince, well-versed in sensuous flirtation. Similarly Radha, Krishna's divine consort was not portrayed as 'a willowy maiden' but an accomplished princess. The painted situations are equally expressive. The palatial setting of the Kishangarh fort was invariably invoked. A few paintings are splendid celebrations of many shades of white inspired probably by the Muhammad Shahi prototypes. A few scenes depict the water sport of Krishna and Radha. The familiar locale of the lotus-studded Gundalao lake is added to symbolize the river Yamuna. The lotus-eyed lovers enjoy the boat ride with sumptuously dressed companions in an evenly lighted autumnal moonlight or in the most dramatic twilight with darkening clouds around. The bowers *(kunj),* fragrant with the garlands, were the secret meeting places, Nagari Dasa's poetry abounds with allusions to them:

And when the sun was setting in the west, the lovers sailed along the Jamuna stream.

To music from the *sakhis* mingling with the murmuring of each wavelet's crest

And the dipping of a single oar.
By lotus banks the long canoe its burden bore.

Past marble palace and temples gleaming white and low green hills athwart a crimson sky.

Betimes its keel caressed the shore where rose a *kunj* of beauty unsurpassed.

Half clad with lengthening shadows of the night. And as he aided her alight.

He led her deep into the darkling grove where love alone can find its way.

And nought can mar this bliss till dawn of beauteous limbs entwined.

(tr. K.J. Khandalavala)

Needless to add, the backgrounds lost all the exactitude of topography to signify a world of comfort, security and order.

Hunting scenes from Kishangarh put forth altogether different aspirations of the life at court. Some of the rulers had a remarkable passion for hunting and maintained hunting preserves. Compared to the matchless Kota hunting scenes they are less fanciful in the delineation of the lush growth of shrubs, bushes and trees as also in the 'super-real' detailings of a wide variety of beasts. Closely related to this genre were the equestrian portraits of the ruling princes, highly conventional and charged with energy and spontaneity.

Raj Singh's atelier attracted painters from Delhi as early as 1719. Bhavanidasa was one such prominent painter, who worked with his son Dalchand and a relative Kalyandasa. Nihal Chand's father, Bhik Chand was the son of *musavvir* Dargahmal. His great grandfather, Surdhaj

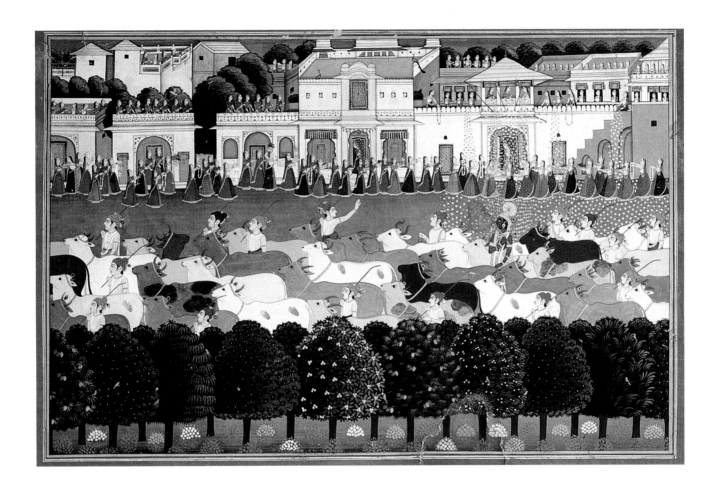

Mulraj came from Delhi during the reign of Man Singh (r. 1658-1706). Thus it may be assumed that Nihal Chand belonged to a family of painters conversant with the time-consuming technicalities prevalent in the imperial workshop of the Mughals. The glory of the sunset sky and the lush greenery of the densely set trees are some of the oft-quoted details of his highly finished landscape backgrounds. He is credited with creating a facial type with elongated features, heavy-lidded eyes, arched brows and a slender neck. In all probability it was based on Banithani herself. A few paintings exist in which this special facial mannerism is reserved only for Radha and Krishna while the other accompanying figures have normal facial structures. It is generally held that Nihal Chand who survived Savant Singh executed some of his masterpieces between 1735-57. Later, Kishangarh painting

The hour of Godhuli. *Jaipur, c. 1780; 55 x 29.2 cms. National Museum (No. 49.19:295).*

The gopis adoring Krishna's footprints. Jaipur, Rasapanchadhyayi *series, c. 1820, 21 x 14 cms. Ashok Kapoor Collection.*

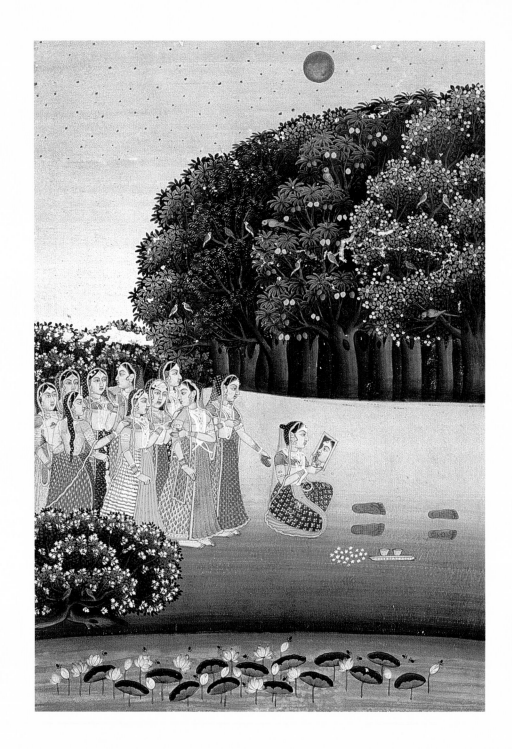

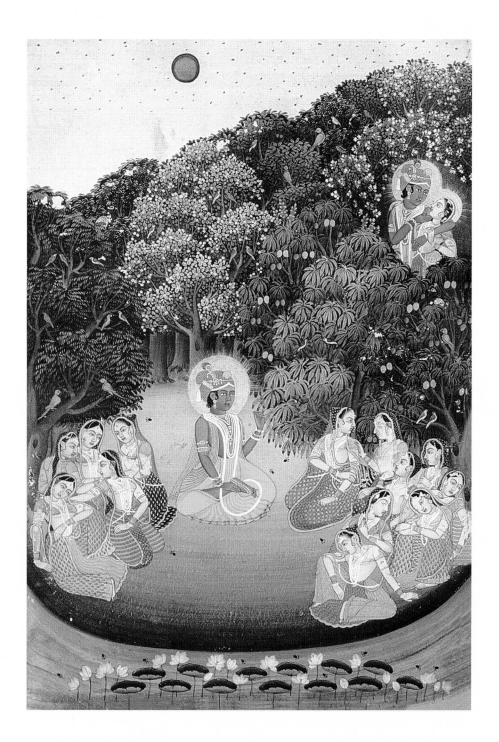

Gopis surrounding Krishna who reappears in the grove accompanying the specially favoured one. Jaipur, Rasapanchadhyayi series, c. 1820; 21 x 14 cms. Ashok Kapoor Collection.

slowly tended towards a generalized treatment prevailing in the other contemporary schools. The visions of a pastoral paradise, frequently encountered in Nihal Chand's creations were too subjective to become routine conventions.

Savant Singh died in 1764 and Banithani a year later. Nihal Chand, according to the evidence available, worked till 1780. Sardar Singh (r. 1757-66), son of Savant Singh, revived painting activity at Rupnagar after the division of the state in 1756. Nihal Chand was reinstated after a brief phase of political chaos and his sons, Sitaram and Surajmal, also worked in the royal workshop of Sardar Singh. The paintings belonging to the regnal years of Raja Kalyan Singh (r. 1798-1838) represent the final phase of the Kishangarh idiom. *Musavvir* Ladli Das worked for him. An illustrated copy of the *Gitagovinda* was one of the last major commissions to be taken up by the painters. Alongside the depictions of the *Krishnalila* theme, was an equally expressive treatment of the epic *Ramayana*.

JAIPUR

~

The Jaipur school represents one of the most popular yet least known group of miniatures from Rajasthan. In the 18th and early 19th centuries Jaipur miniatures were exported all over the country. Jaipuri wall decorators, known for their skill in lime fresco painting *(arayesh),* worked in different parts of north India and invariably influenced the regional idiom.

The Kachhvaha chiefs of Amber were still relatively obscure at the time the Ranas of Mevar dominated Rajasthan. Surrounded by the ruler of Marvar, the Lodis and the Surs, they wisely submitted to the mighty Mughals. Raja Bhagvandasa (r. 1575-92), one of the powerful nobles of Akbar's court, seems to have been the driving force behind the emperor's Rajput policy. Kachhvaha glory reached its peak when Raja Man Singh (r. 1592-1614) was deputed by the Mughals as governor of eastern Indian provinces. Aspects of Mughal culture found unhindered expression in the region. Once Mirza Raja Jai Singh (r. 1621-67) even incurred the wrath of Jahangir for constructing the Jai Mandir and Sukh Nivas palaces at Amber, on the lines of the structures at Sikri and Agra. Savai Jai Singh (r. 1699-1743), founded in 1727 the planned city of Jaipur, the new capital. He also brought two painters, Fazl Mohammad and Sadiq Mohammad from Delhi.

The states of Amber-Jaipur were the foremost in absorbing all the displaced skills of the Mughal *karkhana.* The arrival of painters at different points of time proved crucial to the phases of development of the Jaipur school. Popular Mughal elements, in a fluently modified form recurred in the painting of Amber till the early decades of the 17th century. The

Rajasthani painters, while studying the intricate details of the foliage patterns and clustered blossoms, discovered a delightful range of patterning. Scrupulous presentation of facts, as may be noticed in the Mughal tradition, was suitably replaced by the representation of types, enriched with symbolic connotation. Such visual metaphors can be best analysed in the light of thematic requirements a painter had to respond to. The vigorously stylized tree forms of the Mevar master Sahibdin (left) seem to burst into blossoms in a spring afternoon, the best hour for the rendition of the symphony, Ragini Sarang. *In the woodland setting of a Jodhpur painting (centre) one notices swashing rhythms of the plantain leaves and lush splendour of emerald, acid-green, viridian and olive shades. In an almost contemporary Jaipur miniature (right) we see a much controlled painterly treatment to add depth and volume in the massing of tender little foliage; lively details of the birds illuminate the deeper ranges of the bowers on the banks of the river Yamuna.*

next phase was marked by figural and architectural elements, as well as general conventions of composition and subsidiary ornamentation of the late Jahangir and Shahjahan period. Under the patronage of Savai Isri Singh (r. 1744-51) and Savai Madho Singh I (r. 1751-68) a new style emerged as the Mughal influence reached its final stage of 'genuine influence.' Compositions had fewer intersecting planes. The detailing done in darker hues, very often made the figures look rigid. The two patrons systematized

the functioning of the *suratkhana* and also rearranged the large royal collection of paintings belonging to the earlier era. The painters were furnished with costly papers. In order to enhance the sumptuous effect of the royal portraits, pearls and crystals were fixed on the paintings. Savai Pratap Singh (r. 1778-1803), a poet and a devout Vaishnava, was more interested in commissioning illustrated volumes of religious texts. Dressed up as Krishna, he used to re-enact the divine *rasamandala*, the circle dance, with his concubines

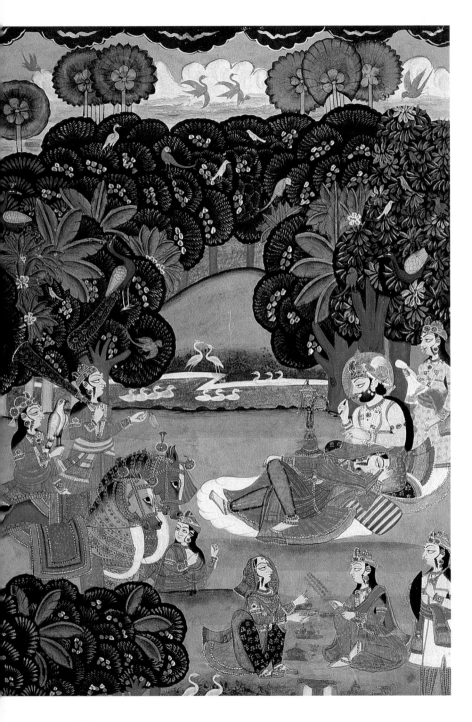

playing the role of *gopis,* the herdswomen in love with the lord. The painters immortalized such performances by portraying Pratap Singh garbed as Krishna dancing or enacting various *lilas* (vignettes based on the life of Krishna).

In the 19th century, strong, unsubdued colours and quickly executed outlines became the primary aspects of Jaipur style finding expression through standardized reinterpretations.

JODHPUR (MARVAR)

Marvar or Maru, the 'Land of Death' is the largest state of Rajasthan. This much fabled kingdom in western Rajasthan had a rather humble beginning in the 13th century. Rao Sheoji, 'the *Rathore* invincible in battle,' first gained control over Pali, situated south of Jodhpur. Descendants of the *Rathore* clan were 'the fiercest fighters.' Their chivalry was celebrated for centuries by bards *(charan)*:

No host so generous as the *Deora,*
No donor so liberal as the *Gaur,*
In pride none equals the *Hada,*
In arms none surpass the Rathore.

Mehrangarh fort at Jodhpur, the stronghold of Marvars was founded in A.D. 1459 by Rao Jodha, the fifteenth in

the line of accession. A land of meagre agricultural resources and of unkind climatic conditions, its residents were proud, brave, god-fearing and hardy. With the union of Jodhpur and the imperial house through marriage, Raja Udai Singh (r. 1583-95) began 'inhaling the breeze of imperial power' which 'spread a haze of prosperity over Maru.'

Jaina merchants of the region seem to have patronized the prevalent style of manuscript illumination in the 15th century. Thirty-seven horizontal *ragamala* paintings (dated 1623) from the commercial town of Pali by the scribe/artist Pandit Virji are the earliest comprehensive records of nascent Marvar idiom fed on Jain, a certain coarsened popular Mughal and *Chaurapanchashika* tradition. Freak idiosyncracies predominate figural stylization while the architecture and an easy landscape vocabulary was enhanced with patches of black sky. However, these visions of melodic modes studded with briskly rendered details had a draughtsmanly vigour, quintessentially folkish. The marriage of Udai Singh's daughter with prince Salim in 1586 intensified the impact of Mughal court culture. Both Udai Singh and his son Sur Singh (r. 1595-1619) were portrayed individually and their documentary likenesses were also included in *Akbarnama* illustrations and *durbar* scenes of Jahangir era. Sur Singh's portraits

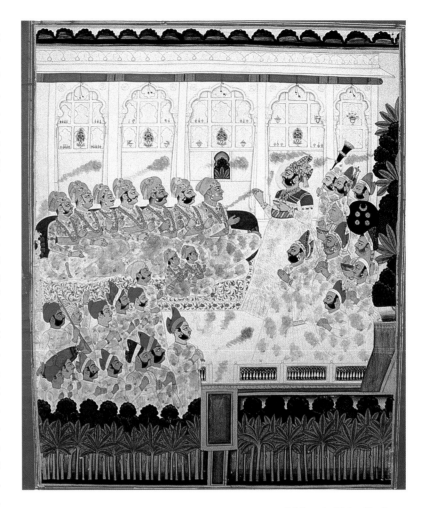

by Bishandas have been found in Mughal *muraqqas*.

Some of the outstanding examples of Mughal portraiture once in the Marvar royal collection include portraits of Maharaja Gaj Singh (r. 1619-38), either alone beset in a balcony *(jharokha)* or sharing a common throne-like seat with the Mughal prince Shah Shuja. The latter has been attributed to Bichitr, 'a brilliant

Maharaja Bhim Singh (r. 1793-1803) and nobles celebrating the the festival of colours. Jodhpur, c. 1795. Private Collection.

Facing Page

Maharaja Man Singh (r. 1803-43) with his female retinue resting in the grove. Jodhpur, c. 1820. Private Collection.

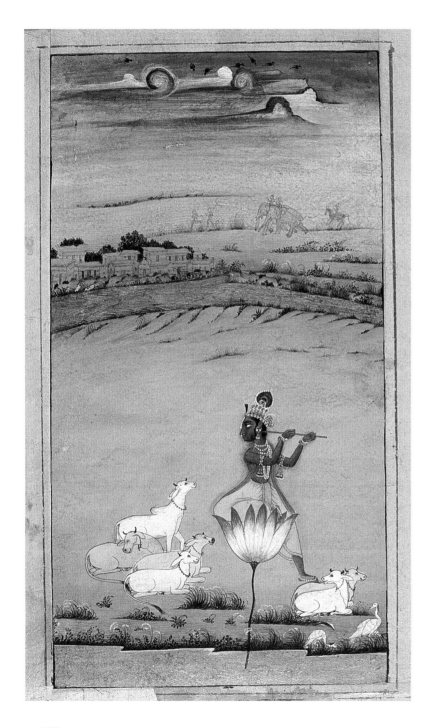

young follower of Abul Hasan.' To this Mughal-inspired group also belong several unfinished group portraits of Maharaja Jasvant Singh (r. 1638-78) seated in the *durbar* with the courtiers. One can easily detect in them elements of the realism of the Shahjahan period. These unfinished paintings are probably the creations of a master of the imperial workshop active either in Delhi or at Jodhpur. Dalchand, the accomplished artist of Delhi atelier joining the services of Abhay Singh (r. 1729-49) introduced the cool perfection of technique derived from early 18th century Mughal prototype. Steadily the able integration of strong echoes of the Mughal manner with observed details became frail. Finally, the indigenous linear perception coupled with a non-representative colour scheme reasserted itself in c. 1730. A few Bikaneri painters joined the local atelier, while several Jodhpuri ones migrated to Bikaner.

A distinct Jodhpur style developed during the reign of Ram Singh (r. 1749-51) and Bijaya Singh (r. 1752-93). Painters concentrated on palace activities as well as on the themes of revelry in the ladies quarter, music and dance performances in the garden, hunting episodes and falconry. Man Singh's (r. 1803-43) adherence to the Nath sect caused him to commission numerous paintings of his revered spiritual advisors, especially that of Ayas Devnathji, as also large-scale illustrated hageographical literature of the order.

Faces in profile with rounded foreheads, elongated eyes with edges upturned and slightly hooked noses are distinct stylistic features of this phase. The same painters continued to paint for Takhat Singh (r. 1843-73) in a closely similar style, identical subjects exuding a sense of sheer luxury. From 1860 onwards the newly introduced art of photography gradually eclipsed the trend of idealized portraiture and *durbar* painting.

BIKANER

~

Prince Bika of Jodhpur established this state in A.D. 1488. Rao Kalyan Mal's submission to Akbar and Rai Singh's (1571-1612) matrimonial alliance with Prince Salim in 1586 brought a profound economic and political change to this poor kingdom lying amid arid wastes and endless sand dunes. Rulers of Bikaner were made eminent grandees of the Mughal court and bestowed with the highest attainable rank in the army. They were sent in crucial military campaigns to Afghanistan and Deccan. *Ustas,* or professional-caste artists, joined Bikaner during Rai Singh's reign and continued to work for generations till the 19th century.

Retrenched from imperial atelier, Ustad Ali Raza (1645-70), his son Jamal Khan and among other *Patshahi* Loko, *Patshahi* Bal Mukund and *Patshahi* Dalpata served Maharaja Karan Singh (1631-74) when he was stationed in Deccan. Ali Raza locally designated as a *Patshahi Karigar* or *Ustad* (imperial artist or master painter) set a 'new and long-lasting trend in the Bikaner school.' Karan Singh's dream vision of Lakshmi Narayan enthroned in the Vaikuntha heaven was splendidly painted by him around 1650 for the Maharaja's private worship. His compositional device of clustering figures, lithe and overpowered with Mughalized features, against soft tonalities of blue, brown and terra-verde was well assimilated in the style of his followers Ruknuddin, Natthu and Isa. Bikaner idiom achieved 'the refined stylistic synthesis' under Maharaja Anup Singh (1669-98), an enthusiastic collector of manuscripts and a patron of art. To the ongoing Rajput adaptation of the Mughal prototype was now added a distinct intensity of palette and elements of fantasy borrowed from Golconda and Bijapur schools. Head of the atelier, master painter Hazi Ruknuddin gave a distinct orientation to the late 17th century style. Responsible for visualizing many remarkable series, he invariably worked on thematically crucial and pictorially challenging compositions. His son Ibrahim inherited his father's artistic flair and technical virtuosity and was later put in charge of the royal studio. Paintings from other schools, as also European prints kept in the royal painting store, were made accessible to the artists who derived many a seminal painterly

Facing Page

*Goddess Durga killing
the buffalo demon.
Jodhpur c. 1825;
23.2 x 27.2 cms. S.S.
Backliwala Collection.*

device from such treasures. The process continued as late as Zorawar Singh's (r. 1736-45) early years of patronage with Ruknuddin's successors active in the royal studio.

By the mid-18th century the style showed a remarkable departure from the Mughalized idiom of the 17th century. The paintings of the last phase were marked by hurriedly brushed landscape elements and impressionistically drawn figurative details, increasingly following the Jodhpur idiom. The impact of decadent late Jaipur style and attempts to imitate unsuccessfully the *chiaroscuro* and perspectival expanse of European models were the factors behind the prosaic workmanship of the 19th century.

Compared to other Rajasthani schools, Bikaner has a large number of dated and inscribed paintings and a plethora of archival records presenting the dates of periodic inspection (*sambhala*) of the royal store of paintings, details regarding the social status and privileges enjoyed by the artists and lastly, the facts to establish unbroken chains of artist families. To present paintings as *nazar* (expressions of unwavering faith and respect) to the patrons on festival days continued till the last phase very much a popular custom among the traditional painters.

MALVA

Located in central India yet sharing the common boundaries with Mevar, Bundi and Kota, the Malva region was apparently under the strong cultural impact of Rajasthan. The painterly idiom, though geographically speaking a central Indian manifestation, was characteristically Rajasthani in feeling, execution and symbolic import. Painted in Malva and Bundelkhand they were sold all over Rajasthan. Malva painting of the 17th century flourishing at the capital city Narasinghagarh and also at Nusratgarh, had a rare boldness of design and exciting colour contrasts very near to the dramatic effect of *Chaurapanchashika* series. The arched line of horizon allows a narrow band of the sky occasionally enhanced with indigo squiggles to peep through. Flat backgrounds of intense primaries have specific non-descriptive overtones while the figures having strong contours act more like motifs in the visualized action pattern. The vigour and simplicity of the 17th century Malva miniatures, however, failed to influence the painters of the following century who instead reverted to a more generalized stylization.

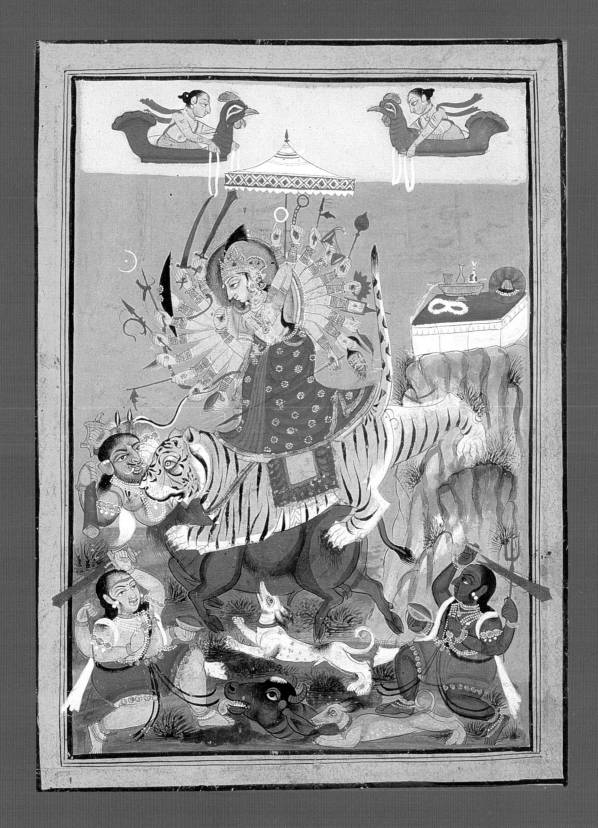

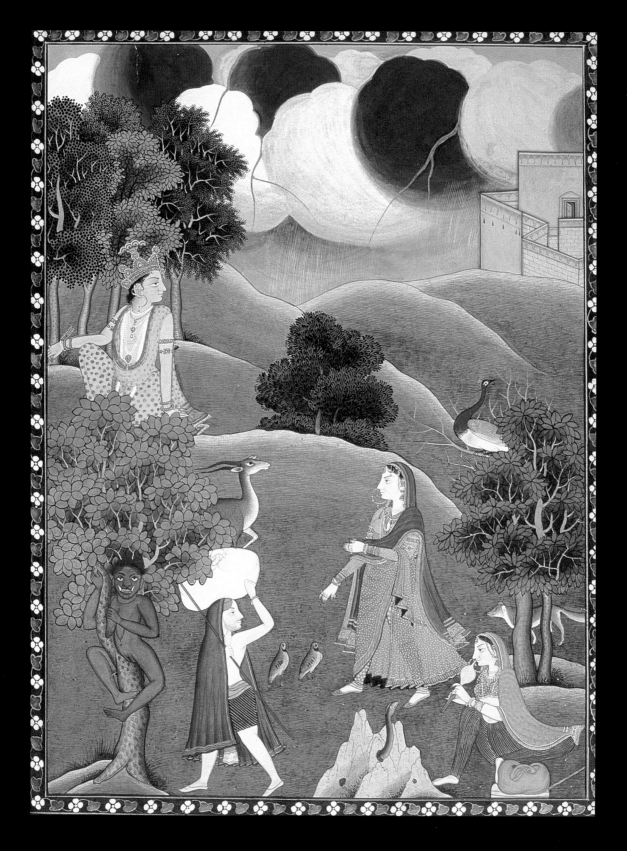

PAHARI PAINTING

The art of miniature painting that found patronage in the Rajput princedoms of the Punjab (now Himachal Pradesh) and Garhwal hills came to be known as the Pahari School. It developed during the late 17th centuries and flourished down to the 19th. The precision of a Mughalized realism and a symbolism derived from classical and medieval literature were combined; the sublime and sensuous were lyrically woven together. Besides, the beauty of the local landscape played an important role in some of the great works painted in the Pahari ateliers.

In the illustrations of Vaishnava themes, the backgrounds with hillocks, gushing rivulets, green meadows and a variety of flowering trees and creepers were meant to represent the area around Vrindavana and Mathura. In the process of such a transformation, the objective sense of place was invariably fused into the mythical. Coomaraswamy, expounding on Rajput painting, presented seminal ideas which are also valuable for appreciating the Pahari Schools:

> ...their ethos is unique: what Chinese art achieved for landscape is here accomplished for human love ... Rajput art creates a magic world where all men are heroic, all women are beautiful and passionate and shy, beasts both wild and tame are the friends of man, and trees and flowers are conscious of the footsteps of the Bridegroom as he passes by. This magic world is not unreal or fanciful, but a world of imagination and eternity, visible to all who do not refuse to see with the transfiguring eyes of love.
>
> (*Rajput Painting*, 1916, p. 7)

The principal centres of Pahari painting were Basohli and Chamba situated on the banks of river Ravi, Jasrota, east of Basohli and Mankot and Jammu (on river Tavi),

Facing Page

The one who goes out to meet her lover. Late Pahari, dated c. 1863; 29.5 x 21.7 cms. National Museum (No. 58.21:8).L. Bharani Collection.

both north-westwards of Basohli; Hariput-Guler on the Banaganga river and Kangra, some twenty miles away from Guler, on the Beas river. To the east of Guler and Kangra are Mandi and Kulu. Tehri-Garhwal on the river Alaknanda also drew painters who came to settle from Guler-Kangra in the mid-18th century.

Several Rajput ruling families came from Rajasthan, central India and even Bengal to settle down in this remote northern region. Compared to the courts of Rajasthan, the area remained relatively untouched by the strong Mughalizing impulse. No matrimonial alliances with the Timurid house were sought. From Akbar's reign, the Pahari rulers became tributaries of the Mughals. Jahangir tried to establish suzerainty in the Himalayan foothills by subjugating the ruler of Kangra successfully in 1618. A year later Jahangir personally visited Kangra with some Muslim divines to celebrate the victory and erected a mosque in the Kangra fort. The Mughal *kilahdar*, or fort incharge at Kangra was deputed as administrator of the area. In 1656, Prithipat Shah of Garhwal finally submitted to the Mughals. Besides paying the levy, he sent his son to serve at the imperial court.

Mughal miniature painters were evidently not invited to the hill-states at this point of time to share their skill with or impart their technical knowledge to the local artists, the *tarkhan* or *tarkhan chiteras*. The *tarkhan* who worked in the Pahari ateliers belonged traditionally to the carpenter class. Besides decorative woodwork, their artistry was seen in other spheres namely, metal craft, jewellery making and in architectural blueprints. A young boy of the *tarkhan* family eager to become a *chitera* and to serve at some court atelier learned the art under his father or uncle who 'imparted lessons, made corrections and kept a stern, demanding eye on the work of his pupil.' Alongside the rigorous 'training of the hand' and 'sharpening of the eye' he was also familiarized with ancient Hindu myths and fables. Collections of preparatory drawings in the family were copied at times, with changes being introduced perceptively in the composition as well as in the colour scheme. When a painter accepted a commission under a new patron or if he moved from the centre where the family traditionally worked, he had to update or modify his expression.

A story in which the name of the Pahari painter or patron is never revealed, documents the relationship between an artist and a true patron, a *sahridaya* or one 'having a heart,' or an imaginatively gifted spectator. The painter hardly cares for the rewards of his wealthy patron. For him what really matters is the critical appreciation of the intrinsic aspects of his creation by an experienced viewer or a *rasika*, by a genuine connoisseur. The story runs as follows:

...a painter who without having been specifically commissioned to do this, once brought a painting of the *Svadhinapatika nayika* theme – a heroine who has full command over her lover – to a Raja. As the painter entered the court, he saw the Raja seated with his confidants and companions. Hesitantly, the painter presented the work which the Raja held briefly in his hand. It looked like a well-rendered version of the *nayika*, using the usual iconography of this *nayika* or heroine: she was seated on a raised throne-like stool while her lover sat on the floor, taking one of her outstretched legs into his lap and massaging the sole of her foot with devotion in token of submission, tenderness, homage. Recognizing the *nayika* rather quickly, and generally pleased with the work, the Raja passed the paintings to his companions, each of whom had words of praise. The Raja then ordered a functionary to give the painter a reward of one hundred rupees. The painter has been closely watching the Raja's reactions to the work on which he had lavished great care, and was disappointed that the Raja had spent so little time in examining it. Convinced that the subtlety he had brought to his work had not been fully appreciated, the painter humbly requested that the painting be given back to him, saying that he was not interested in parting with it. The Raja was surprised, but, being still in good humour, ordered that the reward be doubled. Nonetheless, the painter wanted his work back, and it was now returned to him. Wrapping the painting in his simple cloth-bag, the painter requested permission to leave, risking the Raja's wrath. He was not detained and he left the palace, dejected that his skills seemed not to have been properly appreciated. But in the bazaar he was halted by a goldsmith, who had spotted him walking away with the cloth-bundle under his arm. The goldsmith beckoned the painter and asked him what new work

Raja Medini Pal. Basohli, c. 1730, 22.5 x 20 cms. National Museum (No. 47.110:360).

he was carrying. Resignedly, the painter sat down, opened his bag and showed the very same painting to the goldsmith who took it in his hands and looked at it long and fondly. Finally, placing the painting on the floor of his shop, the goldsmith joined his hands in salutation, bowed his head and spoke words of high praise to the painter, making him out to be a great master of his craft. Taken aback by the goldsmith's compliments, the painter asked what he had seen in his work that merited such words. The goldsmith replied that he had seen many paintings of the same theme, the *Svadhinapatika nayika*, but it was the first time that a painter had placed a full-blown rose in the hand of the lover as he bent at the feet of the *nayika* to massage them. It is as if his palm would have been too rough for the tender feet of his beloved, and he had taken the softest thing that he could think of to massage them with. Despite this, the *nayika* was shown stretching out her arm coyly, as if asking the lover to stop, for even this was too rough for her delicate feet! Startled by this sensitivity of response on the goldsmith's part, for this was precisely the delicate, innovative variant that he had introduced in a well-worn theme, the

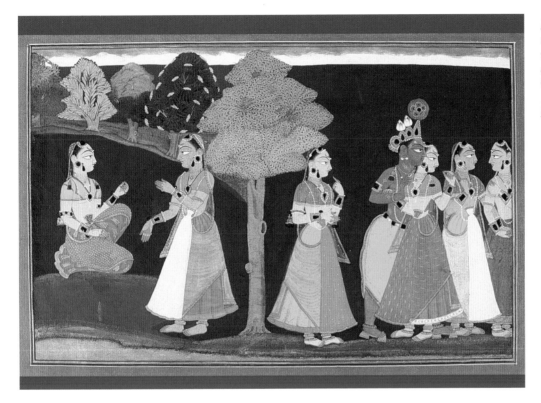

Krishna in dalliance with the gopis *while Radha relates her pathos to the confidante. Basohli,* Gitagovinda *series, dated 1730; 25.7 x 16.5 cms. National Museum.*

painter in turn bowed to the goldsmith, recognizing in him a true *rasika*. The story says that he then got up, offered a few rupees in homage to the goldsmith besides the painting of which he made him a gift, and walked away.

(B.N. Goswamy and E. Fischer,
Pahari Masters, p. 9)

The works of the Pahari masters provide a glimpse into their world. Inscriptions or colophons routinely mention names of the artist, patron, the date and place of execution. On the other hand revenue records and *bahis* or priest's registers with incidental information about the families of Pahari painters maintained at places of pilgrimage, such as at Haridwar, Kurukshetra and Pehowa, provide us with valuable biographical details to reconstruct the genealogies of some painter families. This in particular highlights the movement of artists from one state to the other and pinpoints the role of the artist families in the evolution of the Pahari style.

Very much like the Rajasthani painters, the Pahari miniaturists' approach was that of a book illustrator. Loose paintings, with the corresponding text

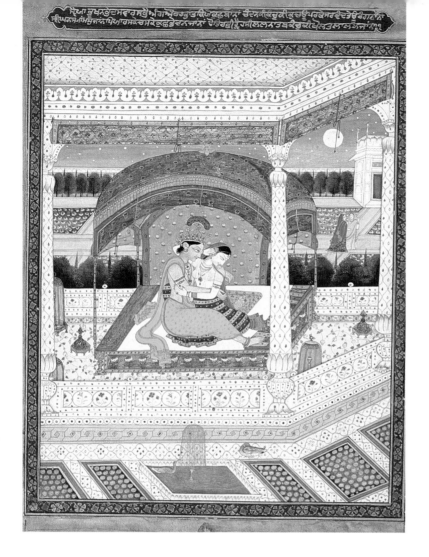

Krishna and Radha in autumnal moonlight. By Sajnu. c. 1815, 26.6 x 22.2 cms. Bharat Kala Bhavan (No. 5450).

written on the back were arranged in a sequence, very much like the leaves of the traditional Indian _pothi_ manuscripts (modelled after the palm-leaf ones). However, no extra attention was paid towards increasing the beauty of the calligraphy. Borders were simpler in the early examples, while in the later paintings they were expanded proportionately and filled with interesting decorative details. Portraits were in every case visualized as independent paintings. Even the representation of activities at the court or hunting scenes were essentially single page paintings.

Narrative situations from the _Mahabharata_ and _Ramayana_, were of cardinal interest for the Hindu patrons. The fourteen years of exile in the forest and the battle between Rama and Ravana, the ruler of the golden city of Lanka are the two major sections of the _Ramayana_. High-key human action with a deep moral note was suitably imagined against accounts of the rainy season, autumn, the dew season and winter. Depictions of Mount Chitrakuta, the river Mandakini and the Pampa lake were also included.

The _enfances_ of Krishna as recorded in the tenth book of _Bhagavata_ was interpreted variously at different centres of Pahari painting. Miraculous acts of Krishna, the divine child, culminated in the slaying of Kansa, the wicked king of Mathura. Again the _Bhagavata_ formed the basis for later poetic elaborations about Krishna the divine lover. The _Rasapanchadhyaya_ section of the _Bhagavata_ perpetuates Krishna's dalliance with the _gopis_ in the blossoming forest of Vrindavana, illuminated with the full moon of autumn, 'reddish like fresh saffron.'

Among the later poetic narratives based on the Krishna-Radha theme, Jayadeva's _Gitagovinda_ was significant in the medieval vernacular literature of northern India. This 'little pastoral drama,' finely

interwoven with song and recitative, provided themes for the Pahari painters as early as 1730. Passionate and intense are the visions of the love of Radha and Krishna, passing through the phases of fervent longing and languishing, pathetic seperation and joyous union. The spring-time woodland setting of Vrindavana, resonant with the love-calls of cuckoos was conceived as an ideal backdrop for such divine love-delights. The very opening lines inspired the painters to match their palette to the thickening clouds in the forest of dark *tamala* trees, and to arrange the bowers on the banks of river Yamuna where Krishna joins Radha in blissful dalliance. The thrilling situation is thus conceived:

> Clouds thicken the sky
> *Tamala* trees darken the forest.
> The night frightens him.
> Radha, you take him home!'
> They leave at Nanda's order,
> Passing trees in thickets on the way,
> Until secret passions of Radha and Madhava
> Triumph on the Jumna riverbank.
>
> (tr. B.S. Miller, p. 69)

Indian literature devoted to the sentiment of love has an impressive combination of the 'intimate knowledge of the passions of the body and soul with the will to codify and classify.' The miniatures of the Rajasthani and Pahari schools will certainly be better appreciated, given some familiarity with the *shringara* literature in Sanskrit and *Brajabhasa*. Indian love poetry goes back to the 1st century B.C. Heroes *(nayakas)* and heroines *(nayikas)* were typecast on the basis of Sanskrit prototypes. *Rasamanjari* of poet Bhanudatta (flourishing in the late 15th century) is one of the early texts to make an elaborate presentation of the *nayaka-nayika* classification. Bhanudatta broadly classifies the *nayikas* into three types namely, the *svakiya* (loving her own Lord), *parakiya* (loving one who is not her own Lord) and *samanya* (impartial).

The late medieval *Brajabhasa* poetry, generally referred to as *ritikavya,* the poetry of mannerism, is marked by the emergence of an essentially romantic outlook and an ornate style. Loaded with repetitive patterns of allegory, metaphors and puns it increasingly became turgid. The conventional concepts and images, borrowed from the Sanskrit *Lakshana Granthas* (treatises on poetics) slowly became worn-out cliches. Nevertheless, poet Keshava Dasa (A.D. 1555-1617), author of *Rasikapriya* (c. A.D. 1591) and *Kavipriya* (c. A.D. 1601), is generally credited with bringing a new diction to medieval literature. *Rasikapriya* (a connoisseur's favourite), a treatise on erotics, enjoyed immense popularity in the feudal courts of Rajasthan and Punjab hills.

In his *Kavipriya*, poet Keshava listed the essential aspects which he thought

The Water Sport of Krishna and Gopis, *Kangra, c. 1780-85, 35.1 x 27.7 cms. Bharat Kala Bhavan (No. 6700). In order to get over the fatigue of the* Rasa *play, Krishna accompanied by the* gopis, *entered the cool waters of the* Yamuna. *The gopis surround him sprinkling the water 'charged with the fragrance of waterlilies' from every side. The painter with his masterly use of silvery grey, soft lilac, green and blue tones tried to interpret the textual description of the* Bhagavata *in all its subtle symbolism. Voluminous tree trunks encircled with the flowering creepers were designed as restatement of the playful embrace of* gopis. *The reflection of the full moon arranged over the head of Krishna symbolizes the full moon of love surrounded by the stars.*

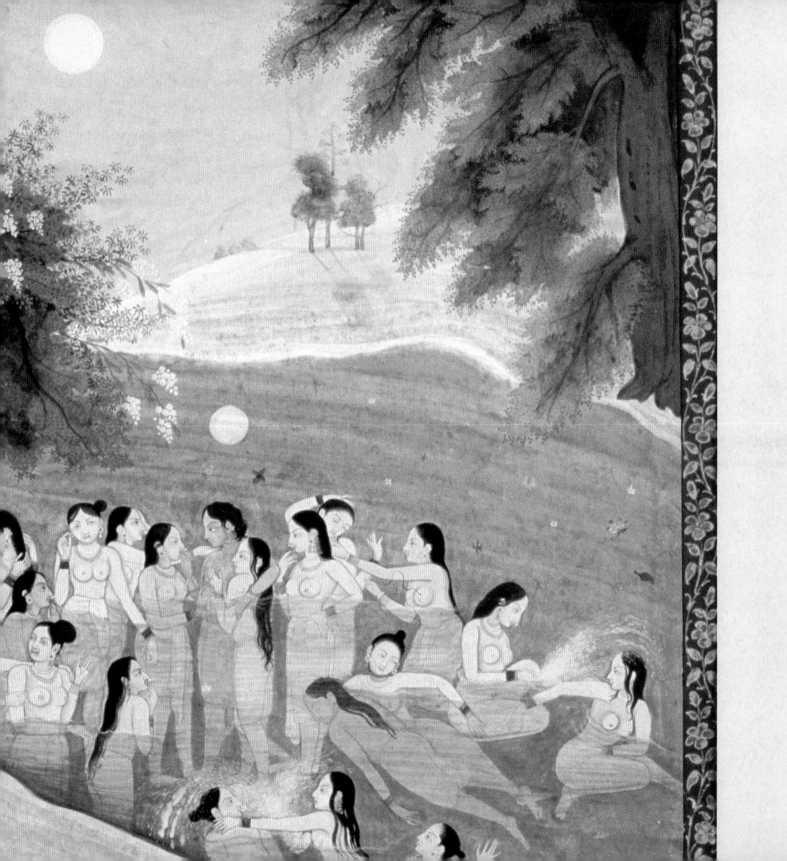

would symbolically evoke associations with the referents of human love. Such poet's pigments found a shining constancy in the painter's brush. Some of the painted *barahmasas* from the Guler and Kangra school, inspired by the poetic metaphors as well as by the landscape of Tira-Sujanpur and Alampur, are highly evocative.

The *Satsai* of poet Bihari (1595-1663) was another *Brajabhasa* text classifying the *nayakas* and *nayikas* and which attracted the Pahari painters of the Kangra valley. Loaded with double *entendre,* each verse was like a little word picture expressing the state of love in union and separation. Radha and Krishna, the *dramatis personae* of the poems, were the ideal lovers. Bihari's description of the *abhisarika nayika* who goes out to meet her lover in the night offers a picturesque situation for the painter:

> Though clad in blue, the dark night cannot hide her as she goes to meet her lover. The flame-like brilliance of her body illumines the night itself.
>
> (tr. M.S. Randhawa)

The classification of musical modes (*ragas* and *raginis*) taken up for illustration by the Pahari painters of Basohli, Kulu, Bilaspur, Kangra and Garhwal was based on the system of Mesakarna, a 16th century court priest of Rewa in central India. In his *ragamala* treatise he listed six *ragas* (fundamental musical mode conceived as masculine), thirty-one *raginis* (musical mode conceived as feminine) and forty-nine *ragaputras* (subsidiary musical mode conceived as sons). He cited a visual counterpart to each one of these modes. In some cases where the painters discovered that the iconography was too abstract, they found it easier to portray situations, activities or animals closely related to the sounds.

Myths related to Shiva and Parvati and to *Devi*, the great goddess, were some of the favourite themes of Pahari painters who discovered many an iconic variation 'immediate yet timeless' at 'the highest pitch of concentration.' The anthropomorphic deities were not just inadvertently set off against backdrops of courtly splendour. The evening dance of Shiva before *Devi* was represented repeatedly. Shiva and Parvati enthroned in a golden pavilion on the snow-capped summits of Himalayas glorified the Lord in all his splendour. The illustrations of *Devi Mahatmya* recaptured the great battles undertaken by the Goddess, in episodic progression. Artists were commissioned to paint series showing her different aspects, ranging from the fierce to the most benign. Such *Devi* series were primarily conceived to help the devotees as veritable 'aids to meditation' *(dhyana)*.

Among the ballads and popular romances, *Nala-Damayanti* which originally appears in the epic *Mahabharata*, became a favourite subject with the Kangra

Allusions to 'earthly elephant clouds' abound in ancient myths. Concentric spiralling of the mass of indigo grey clouds in a Pahari painting (top left) *has apparent resemblance to the elephant's trunk. Metaphors used by the* Brajabhasa *poets to celebrate the sights and sounds of the Indian months of rains inspired the painters. Poet Keshava Dasa's evocative descriptions of the months of* Sravana *and* Bhadra *may be cited. 'The streams look so lovely, as they rush to meet the sea. The creepers enchant the eye, embracing young trees lovingly. The lightning flashes restlessly, as she sports with rolling clouds. The peacocks with their shrill cries announce the mating of earth and sky. All lovers meet in this month of* Sravan, *why forsake me then my love?'* (Sravana) *and, 'The purple clouds are gathering, the thunder rolls and rains pour in torrents. The wind blows fiercely, cicadas chirp, the lions roar, and elephants fell the trees. The day is dark like the night, and one's own home is the best. Pray leave me not in the month of* Bhadon, *for separation pains like poison.'* (Bhadra)

painters. An elaborately painted set of pictures became an ideal gift to be sent along with the dowry. Two other folk romances of the Punjab, *Sohni-Mahival* and *Sassi-Punnu* were also popular subjects. *Sohni-Mahival* is the tale of the ill-fated lovers; of Sohni a village belle and Mahival a cowherd. The tale has a tragic end when Sohni's baked clay pot is replaced by an unbaked one and which she uses as a float while crossing the river to meet her beloved one night. She drowns mid-stream. The story of Sassi, who was brought up by a washerman, and Punnu, the scion of a prosperous merchant family, has a similar tragic ending.

The development of Pahari painting in the mid-18th century followed political changes in the region. By 1798, Maharaja Ranjit Singh (1792-1839), consolidated Sikh power and expanded his territory, making Lahore his capital. He also deflected the expansionist zeal of the Pahari rulers, notably that of Sansar Chand of Kangra. The Gurkhas invaded Garhwal in 1803 and a little later Kangra in 1806. Sansar Chand was thus left with no option but to approach Ranjit Singh for

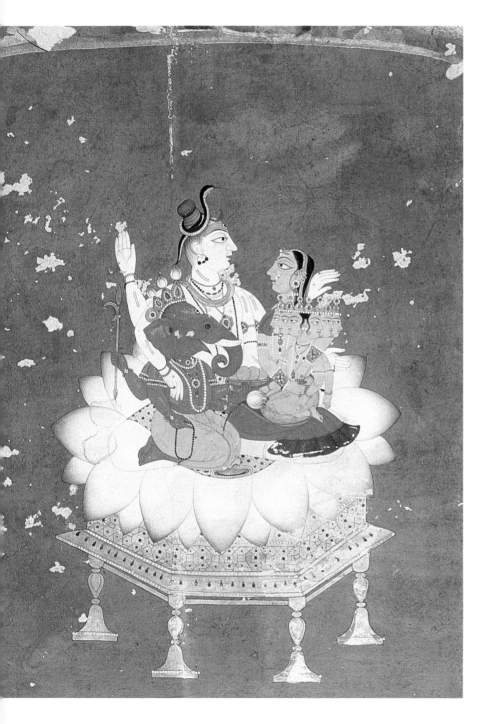

assistance. After expelling the Gurkhas, the Sikhs assumed direct control over the hill-states by 1822. As vassals, their rulers had to attend court at Lahore periodically.

An isolated example of 16th century painting from the Pahari region, is the illustrated copy of *Devi-Mahatmya,* in the pre-Mughal, *Chaurapanchashika* idiom. Dated to A.D. 1552 the series originated in the once important town of Jayasingh Dev Nagar or Jaisinghapur in the Kangra region. The painter, in all likelihood was an itinerant one from the plains, who over time must have absorbed various significant local religious and cultural aspects. Echoes of his highly expressive chromatic rhythms and a pithy linear interpretation of the human limbs lingered for a while until 'the air became filled with new voices' leading to a startling change of key.

BASOHLI

The ancient name of Basohli was Vishnusthali. The area comprised a group of seventy-four villages which are now part of Jammu-Kashmir state. It is difficult to surmise exactly when painting at Basohli started, but some of the characteristic idioms of the school became manifest in the miniatures produced in the second half of the 17th century. The friendship between the Basohli ruler Raja Sangram

Pal (r. 1635-73) and Prince Dara Shikoh is known. The Basohli ruler, in all likelihood, had ample chance to see the albums of painting in the royal Mughal collection and as has been suggested by some art historians, it led to a few artists' migration to Basohli.

In his later years, Sangram Pal became an ardent Vaishnavite, supplementing the traditions of Shiva and *Devi* worship in the region. A well-known illustrated series of the *dhyanas*, descriptions of the inwardly experienced images of *Devi*, belonging to the period 1660-75 is the earliest example of Basohli painting. The two other sets of paintings which followed were markedly different in theme. They seem to reflect the gaining popularity of the cult of *bhakti*, passionate devotionalism, expressed in the adoration of Krishna. These were, a *Nayaka-nayika bheda* series and illustrations to Bhanudatta's *Rasamanjari*. The *Devi* series was certainly not 'meant for ordinary delectation.' Each painting fulfils the iconographic context, glorifying the effulgent appearance of *Devi* against strong monochrome backgrounds of yellows, reds and chocolates. The visual vocabulary undergoes a change in the *Nayaka-nayika* and *Rasamanjari* sets which aim at rendering the entire gamut of the passions 'constantly illumined by the magic of a first kiss.' The ideal hero was presented as the blue god Krishna elegantly dressed in a yellow *dhoti* and wearing a bejewelled crown topped by lotus buds. Elegant scroll-work on the

architectural elements and the patterns of the floor-coverings share a common repertoire of decorative motifs.

Raja Sangram Pal's nephew Raja Kirpal Pal (r. 1678-1695) was a great lover of illustrated copies of manuscripts. He is also credited with the formation of an atelier. Among his artists was Devidasa (active c. 1680-1720), who was 'well-versed in the art of painting.' His name is documented in the colophon of an illustrated set of *Rasamanjari* (A.D. 1695). The land-settlement records mention that Devidasa, son of Kirpal and grandson of Ratto, belonged to a carpent-painter family of Nurpur.

The paintings of the *Rasamanjari* were referred to by the scribe as 'the wealth of the human mind to see the creation of god and realize the hollowness of this world.' This indeed presents the mind of the connoisseur who had some feel of the spiritual undertones of *shringara* poetry. Stylistically, the set of 1695 is closely related to the earlier one of c. 1660-70. Yet Devidasa introduced notable changes. Krishna as the ideal lover was substituted by a secular figure in contemporary attire. Highly stylized cloud patterns were replaced by calmer colour washes. The earlier elemental energy expressed in the gestures of human figures was restrained by the inclusion of observed details and earthly proportions.

Dhiraj Pal (r. 1695-1725), as stated by the contemporary chronicler Kahan Singh,

117

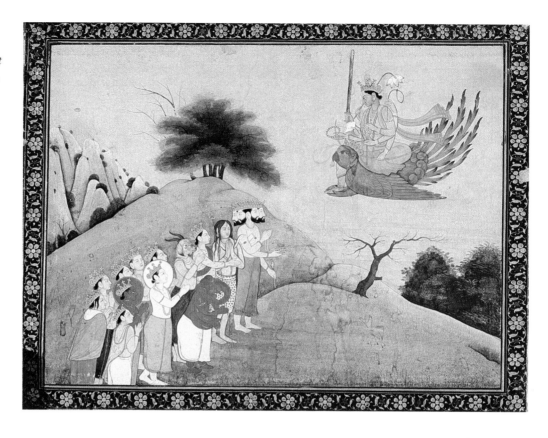

continued to patronize painters at his atelier and to commission illustrated copies of the sacred texts. Some single page paintings of the *nayika* and *ragamala* sets studded with beetle-wing are ascribed to this phase.

A sumptuously illustrated set of *Bhagavata Purana* in the horizontal format was painted at Mankot between c. 1705 and 1710 manifesting some of the immaculate stylistic elements of Basohli.

During the eleven-year reign of Raja Medini Pal (r. 1725-36) was painted the famous *Gitagovinda* under the supervision of Manaku, an artist hailing from Guler. The dated colophon of A.D. 1730, in Sanskrit verse, however, has been interpreted variously by art historians. Yet, it remains unchallenged that this set marks the culmination of the 'crisp, colourful spirit of earlier Basohli painting.' Manaku, intentionally returned to a language of simple conventions, enriched with colouristic aspects, dazzling in their primary values. The pictorial space became a two-dimensional frame which conjured up in the minds of the spectators, the vistas sought to be unfolded. A

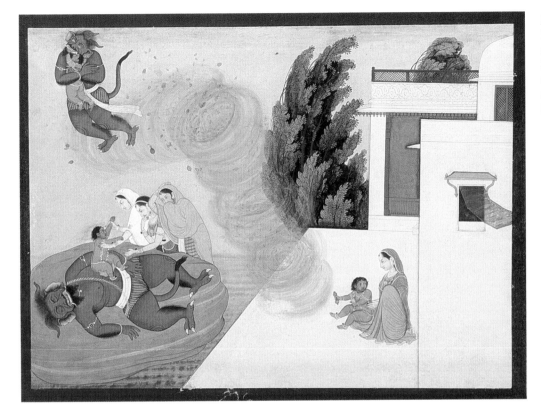

Infant Krishna kills demon Trinavarta, the whirlwind demon. Guler-Kangra, Bhagavata Purana *series, c. 1780-85, 32.3 x 24 cms. Bharat Kala Bhavan (No. 6854).*

circle of trees stood for a grove, while the flowing Yamuna river, placed parallel to the foreground, complemented the circular and diagonal emphasis of the composition.

Raja Medini Pal married the sister of Raja Goverdhan Chand of Guler. He in turn was married to Raja Medini Pal's sister. This indeed helped the influx of the fresh pictorial idiom of Guler, which was definitely charged with the Mughalized naturalism, yet softened considerably to express the lyricism of medieval poetry. Some of the members of Manaku's family,

including his younger brother Nainsukh, moved to Basohli in the early 1760s. Between 1765 and 1770, the highly expressionistic mannerism of the early style became extinct. Significantly, the beetle-wing cases were dropped for obtaining scintillating tactile effects. This phase lasted till c. 1830.

Mankot, a small but once powerful state, was merged with the Basohli state. It is easy to appreciate the elaborate compositions of the *Bhagavata Puranas* series (c. 1700) as a vigorous offshoot of the idiom of Devidasa. Royal portraits may

be placed under a different group displaying subtle details born of astounding observation.

KULU
〜

The painting tradition of Kulu was greatly influenced by the style of Basohli, probably due to the clan associations between ruling families of the two states. Being ardent Vaishnavites they brought an image of Rama from Ayodhya, known locally as Raghunatha, in 1650 and worshipped him as the presiding deity of the kingdom. Rulers of Kulu considered themselves vice-

Goddess Sarasvati. Kangra, c. 1820-25; 30 x 35 cms. National Museum (No. 60.1277).

regents of the Lord. During the prosperous regnal years of Raja Man Singh (r. 1688-1719), a few Basohli painters were invited to paint an elaborately illustrated set of *Ramayana*, known popularly as the 'Shangri' *Ramayana*, after the name of the place where it was traced in the 19th century. 'Shangri' *Ramayana* was painted between c. 1690 and 1710 in a charmingly dramatic modification of the Basohli idiom. Some of the narrative-oriented details evoke a range of emotions, 'pure and raw.' One may also detect the painter's skill in conceiving elaborately crowded compositions. However, the style became more and more generalized by the 1750s. During the reign of Raja Pritam Singh (r. 1767-1806), who commissioned a *Bhagavata Purana* set, is noticeable the emergence of a new style, harshly geometric and stereotyped in its linearization. This phase was followed by a group of painters who engaged in making facile reproductions.

GULER
〜

The small state on the banks of river Banganga was founded in A.D. 1405 by the senior branch of the Katoch family that ruled over Kangra. Raja Hari Chand of Kangra, once out on a hunting expedition, lost his way in the woods and fell into a well. His companions who failed to find

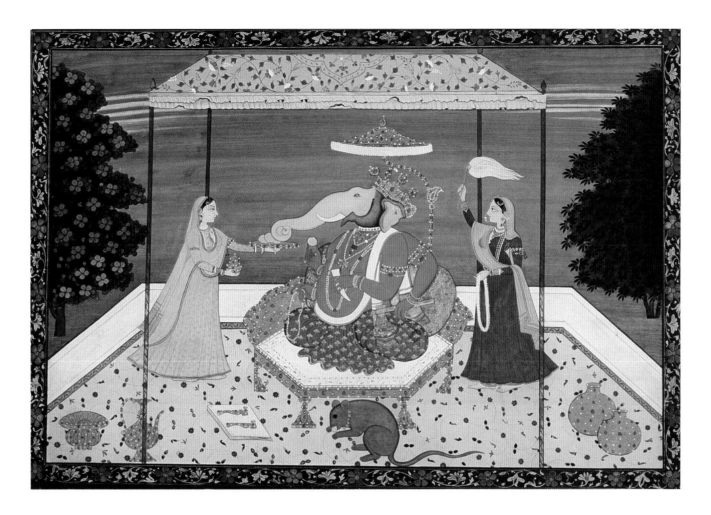

him declared him dead. The Raja survived, but instead of reclaiming the throne of Kangra decided to settle at Guler, making Haripur his capital.

The earliest evidence of painting at Guler are the contemporary royal portraits which may be traced to the period c. 1690-95. None of the works from Raja Raj Singh (r. 1675-95) deal with religious narratives or secular lores. His portrait reveals unmistakable traits of Basohli painting. The artists already employed by Raj Singh continued to work for Raja Dalip Singh (r. 1695-1741). This may be surmised from *Dilipranjani* which chronicles events upto the year 1703.

Pandit Seu *musavvir* (c. 1680-1740), about whom very little is known, was the head of a painter family based in Guler. Supposedly, he travelled from the hills to

Lord Ganesha. Kangra, c. 1815; 31.3 x 21.5 cms. Bharat Kala Bhavan (No. 7).

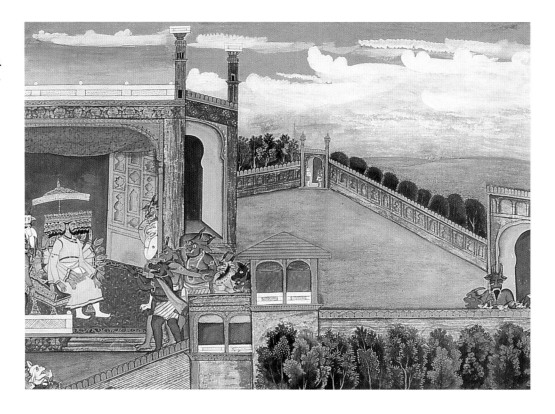

Ravana with his demon messengers. Kangra, c. 1800; 41 x 28.2 cms. C.L. Bharani Collection.

some flourishing centre of Mughal painting in the plains, in all likelihood Delhi or Lahore, and received instruction in the Mughal manner of painting. On his return he introduced the contemporary late-Mughal idiom of Muhammad Shah's atelier in the prevailing style of painting at Guler, sometime around 1725. Prior to this, his expression was much influenced by the archaistic phase of Basohli painting. Figures drawn with striking clarity of line and a spontaneous, abstract interpretation of space are the two striking features of his *Ramayana* series of c. 1725. A gradual loosening of the earlier unified treatment

is visible in several portraits of c. 1730 attributed to Pandit Seu. Among his two sons, Manaku (c. 1700-60), the elder one, appears to have been trained in his father's earlier style, while Nainsukh (c. 1710-78), the younger one, assimilated the stylistic modifications inclined towards Mughal naturalism. Mughal drawing techniques, the palette and a concern for the model's precise features, along with his real identity in portrait studies, became the new elements of the style. Painting at Guler passed through a phase of experimentation when the *tarkhan chiteras* tried to find fresh possibilities of the newly-introduced

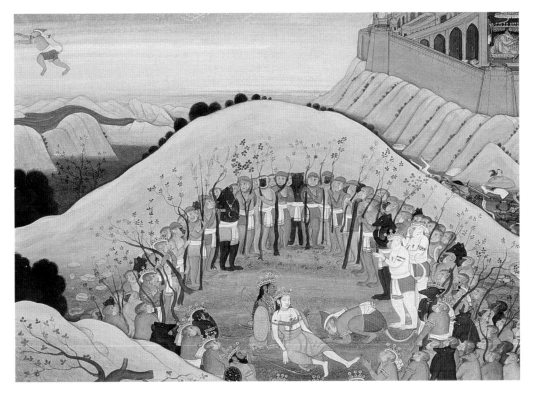

Lakshmana wounded and lying unconscious while Hanumana goes off to bring the magic herb. Mandi, Ramayana *series, c. 1830; 32.2 x 22 cms. C.L. Bharani Collection.*

nuances during the reign of Raja Govardhan Chand (r. 1741-73). A 'deliberate research into physical charm' became increasingly manifest in the illustrations of legend-derived themes as well as in contemporary royal portraits. Artists of Prakash Chand's reign formulated a new facial pattern with straight nose, florid sweep of the brows and slightly tilted chin.

Patronage slackened when the state was subjugated by Raja Sansar Chand of Kangra. He invited the painters of Pandit Seu's family by extending generous patronage to them. The Sikh dominance in the region during the first quarter of the 19th century created a new situation that considerably blunted the highly expressive conventions of the Guler painters.

KANGRA
~

The hillmen of the Kangra valley in one of their folk songs extol the serene beauty and magical calm of their native land:

Oh, Mother Dhauladhar! You have made Kangra a paradise.

Krishna and Radha in the groves. Kangra, c. 1800; 37 x 28 cms. National Museum (No. 66.90).

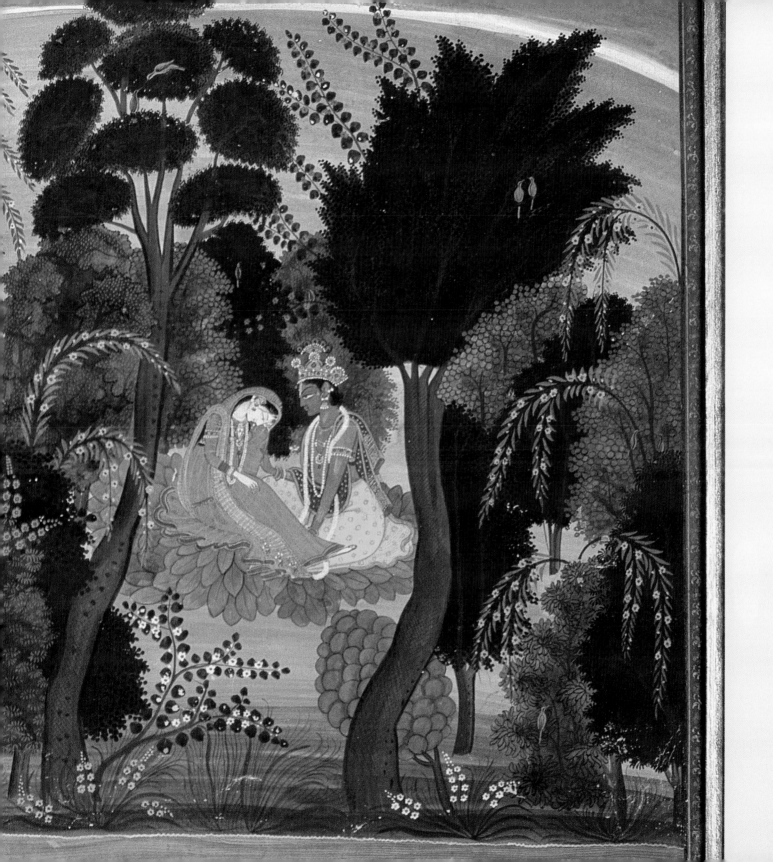

Green, green hills, and deep, deep gorges
with river flowing.
Lithe and handsome young men, and lovely
women who speak so gently.
Oh, my dear land of Kangra, you are unique.

(tr. M. S. Randhawa)

The scenic setting of Kangra inspired the painters who painted in delicate harmonies. The rounded hillocks, with little blobs of green paint shaped like trees may be recognized as simplified landscape motifs. Glorification of female beauty, in all its charming details, remained another preoccupation of the Kangra painters. The poet's description of feminine grace was thoroughly assimilated. Once the inner eye was responsive, the mental image was relocated in life itself. Probably for this reason the human figures are so authentic in their physical details, simultaneously being ecstatic in their sensuous stance.

All the available examples of Kangra painting postdate 1765. The Mughal hold over the massive Kangra fortress persisted till the death of the last *kilahdar* Saif Ali Khan in 1781. In 1786, the fort came under the control of Raja Sansar Chand (r. 1775-1823), the Katoch ruler who was an ardent patron of painting. During the twenty-five years following the siege of the Kangra fort, he made the proverb, 'He who holds the Kangra fort, holds the hills,' come true. He first defeated the ruler of Chamba and in the course of time the princes of Sirmur, Mandi and Suket. Political paramountcy

engendered a mood of 'voluptuous self-sufficiency' that was shattered by the Gurkha invasion of 1806. Sansar Chand was left with no other option but to seek the intervention of Maharaja Ranjit Singh, his rival. But after the expulsion of the Gurkhas the Sikhs assumed control and the Katoch rulers were reduced to tributary status. Sansar Chand spent the years between 1809 and 1823 in 'comparative obscurity' at Alampur, Sujanpur and Nadaun. William Moorcroft who stayed as a guest at Alampur described the daily routine of the Raja:

Raja Sansar Chand spends the early part of the day in the ceremonies of his religion, and from ten till noon in communication with his officers and courtiers. For several days prior to my departure, he passed this period at a small *bungala*, which he had given up for my accommodation, on the outside of the garden. At noon the Raja retires for two or three hours, after which he ordinarily plays at chess for some time, and the evening is devoted to singing and dancing in which the performers recite most commonly *Brajabhasa* songs relating to Krishna.

(*Travels in the Himalayan Provinces*, p. 145)

He elaborated upon Sansar Chand's discrimination in the art of painting, which he was managing to keep up though 'living in reduced circumstances':

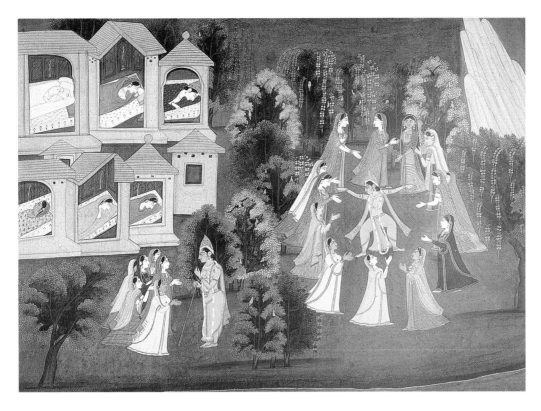

Krishna's ring dance. Kangra, c. 1815; 41.5 x 31 cms. C.L. Bharani Collection.

He is fond of drawing, keeps several artists who execute the minute parts with great fidelity but are almost wholly ignorant of perspective... His collection of drawings is very great but the principal portion consists of representations of the performances and prowess of Arjun, the Hindu Hercules (and) the adventures of Krishna so similar to those of the Grecian Apollo.

(Travels in the Himalayan Provinces)

Though having three queens, Sansar Chand was infatuated with Nokhu, a shepherdess of village Bandla who was married. The folk composers of Kangra celebrated the romance of Raja and Nokhu (later renamed Gulab dasi) in several popular love songs. During his last days at Nadaun he fell in love with Jamalo, a dancing girl. Her enticing company alleviated the humiliation he had gone through at the court of Maharaja Ranjit Singh.

Stylistically, Kangra paintings may be placed in two groups. The first focusses on events at the court, with Sansar Chand as the central figure. The second, is more illustrative in nature and depicts primarily the divine plays of Krishna as recounted

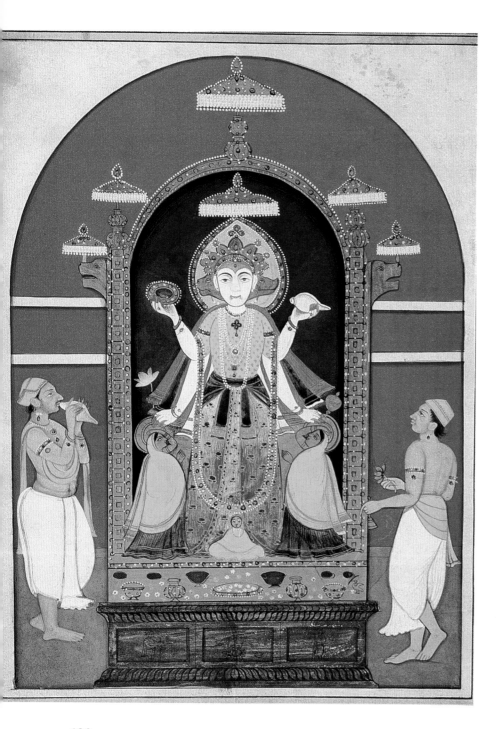

in the Tenth Book of *Bhagavata Purana* and Jayadeva's *Gitagovinda*. To this may also be added the *Ramayana* set which can be best appreciated in the light of textual descriptions. The *Barahmasa* inspired by Keshav Das's *Kavipriya* and the presentation of the *nayaka-nayika* theme based on Bihari's *Satsai* contain some of the loveliest paintings of the Pahari school. A *ragamala* with an emphasis on the compactness of composition, subtle tonal modulation of colour tones and lyrical patterning evoke the inherent spirit of each melody *(raga)* attuned to a kind of 'pictorial paraphrase.'

It is generally held that due to financial difficulties, Prakash Chand of Guler had to curtail the expenditure of the atelier. Among his master painters, two of Manaku's sons, Fattu (c. 1725-85) and Khushala (c. 1730-90), and one of Nainsukh's, Gaudhu (c. 1740-1820) migrated to Kangra seeking employment in Sansar Chand's royal workshop. All the narrative paintings, including the *ragamala* set referred to above were the creations of these masters and can be dated to a period c. 1785-95. The style of the *Bhagavata* and *Gitagovinda*, attributed to Khushala and Gaudhu are difficult to distinguish from the idiom of Guler. Figures were swiftly turned out in flowing linear rhythm. The richness of the flesh tint was enhanced with soft stippling. The beauty of the landscape, reminiscent of Nadaun and Alampur on the river Beas, also played an

important role in these sets. The pattern of composition demonstrates a skillful division of oblong space into units. A careful punctuation of the space is used to demarcate sequences. The rounded structure of the hillocks, with a modulated rendering of planes, was thoughtfully worked out in delicate parallel lines (*khat pardaz*). This technique was undoubtedly Mughal. Touched abruptly with streaks of vermilion, the sky fails to denote aerial depth, but tells of a calculated mannerism.

Purkhu (active c. 1780-1820), who traditionally came from Guler, was also in the service of Raja Sansar Chand. He painted mostly portraits and crowded compositions representing court scenes, festivities, wedding processions and other forms of entertainment. He is also credited with master-minding a few of the narrative sets, namely of the *Shiva Purana, Harivamsha* and *Devi Mahatmya*. Architectural details abound in these narrative paintings and the frame remains ambitiously divided by the diagonals, squares and concentric rectangular units. The figures are slightly squatter in proportion and display certain fixed stances. Even the details of the eyes, hair and fingers are standardized to some extent.

Sansar Chand's son Aniruddha Chand, ascended the throne in 1823 but had to flee to Tehri Garhwal in 1828 as an alternative to the Sikh usurpation of the Kangra state. He married his two sisters to Raja Sudarshan Shah (r. 1815-59). The outstanding series of the *Gitagovinda* and *Satsai* were given as a part of the wedding dowry.

The Kangra idiom, with or without some minor changes, continued at Nadaun. Sikh influence, however, greatly affected the painters' selection of themes as also their modes of presentation.

CHAMBA

~

Chamba, a large state of the Himalayan foothills, borders Basohli on its east and Guler, Nurpur and Kangra to its south-east. The early style of the 17th century found expression in a series of portraits similar in manner to Basohli-Mankot. About 1770, the states of Chamba and Guler were linked through the marriage of Raj Singh's (1764-94) sister to Prakash Chand of Guler. This created a congenial situation for the possible recruitment of painters from the Guler atelier. As a result Nikka (c. 1745 - 1833), the third son of Nainsukh, was invited to join the Chamba court. That his family's idiom was thereby transmitted to Chamba is evident. From about the 1760s, the figures were marked by expressive grandeur and were stylized to a slender structure. Some of the Chamba painters designed the *rumals*, covers for ceremonial gifts, which were embroidered by the ladies of the *zenana*. These court embroideries have rightly been referred to

Facing Page

Adoration of Vishnu-Vaikunthamurti. Chamba, c. 1805; 24 x 18.8 cms. An unusual aspect of the deity combining heads of a boar, a lion, and dshr Kapila (at the back). C.L. Bharani Collection.

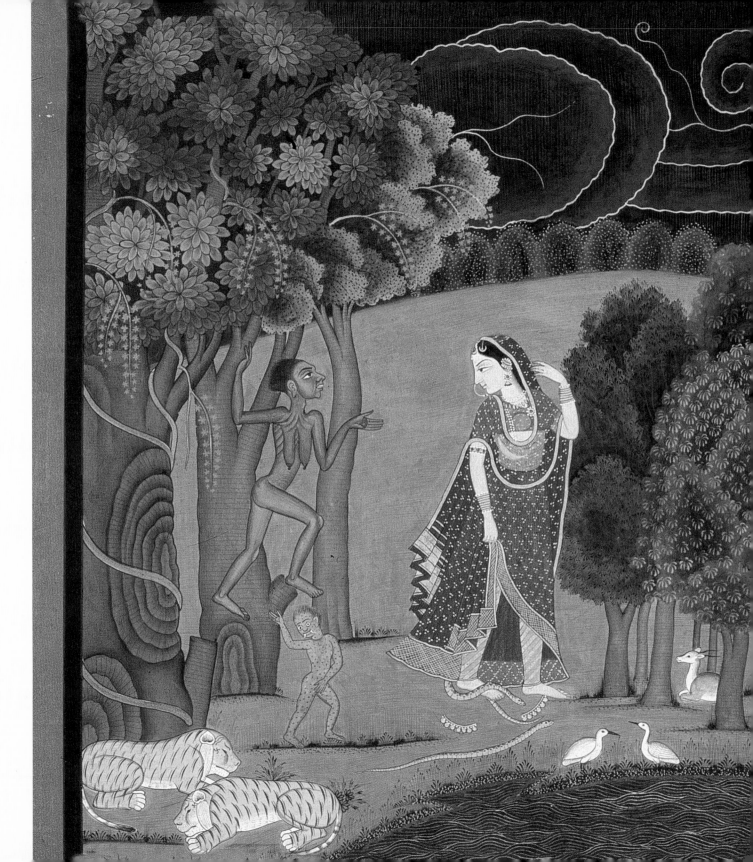

Radha on her way to meet Krishna braving the thundering clouds and the beasts. Garhwal, c. 1800; 35.5 x 29 cms. C.L. Bharani Collection.

as paintings transferred on cotton muslins with needle and floss silk.

MANDI

~

An offshoot of Suket, the state was founded in the 10th or 11th century by the kings of the Sena dynasty of Bengal. Till the second half of the 17th century, a distinct school of painting had not emerged at Mandi. Even the earliest examples, in the form of portrait studies, were least influenced by the neighbouring centres of Kulu and Guler. The portraits of the last decade of the 17th century in all probability were painted by some Mughal artist of the Aurangzeb period who sought refuge in the hill-states. Painted in a palette of earthy hues, the royal portraits tended to exaggerate the normal proportions. The heads were conspicuously oversized. Dark greens, molten browns, reds, indigo and smoke-grey dominated and were touched repeatedly with darker washes. These elements characterized the Mandi style of the early 18th century.

Raja Sidh Sen (r. 1684-1727), the great ruler of Mandi is said to have lived for one hundred years. He was a devotee of Shiva and possessed supernatural powers. Contemporary portraits glorify his robust personality by almost transforming his physical appearance into that of a 'thick-limbed' deity. The portraits of Sidh Sen's grandson Shamsher Sen (r. 1727-81) are equally captivating and in a few he is shown dressed up to look like Shiva.

In 1793, Sansar Chand incarcerated Isvari Sen (r. 1788-1826) of Mandi for twelve long years at Kangra. After his release in 1805, he employed Sajnu (active c. 1790-c. 1830), a painter of Guler distantly related to Purkhu of Kangra. Sajnu's style shows many painterly elements borrowed from Purkhu's idiom namely, a preference for pinkish flesh-tints, for loosely spread out architectural details bereft of perspective and for simplified details. In 1810, he completed a set of narrative paintings based on the ballad *Hammir Hath*, besides working on numerous single page paintings. Painters in Sajnu's circle were active for quite some time. Over time, their works became increasingly harsh and gaudy in their general impact.

GARHWAL

~

At the extreme south-eastern end of the hill-states is situated Garhwal, on the bank of river Alaknanda. A good number of paintings, considered as the masterpieces of Garhwal school are attributed to the painters working in the atelier of Raja Pradyuman Shah (1785-1804). The Guler-Kangra elements persist, though it is difficult to credit any major painter of Sansar Chand's studio with the execution

of these paintings. The facial types, though not identical, are fairly similar. Even certain motifs of the landscape are repeated with little intrinsic change. Any talented pupil belonging to the Kangra circle of Fattu, Khushala and Gaudhu could have made these splendid creations.

Sudarshan Shah (r. 1815-59), very much like his father Pradyuman Shah, maintained an atelier which had Chetu, great-great grandson of Manaku of Guler as a leading artist. Sudarshan Shah's marriage with the princess of Kangra in 1829 and the migration of Aniruddha Chand were also significant in the development of painting at Garhwal. Some of the great sets of paintings once produced for Sansar Chand, became the precious possessions of Sudarshan Shah. It is more than likely that these became the models for constant reference and reinterpretation in the royal atelier.

Rama and Lakshmana meet Hanumana, Sugriva and Jambavan to discuss plans for the battle against Ravana. Shangri Ramayana *series, Mandi, c. 1700-10; 28.2 x 18.8 cms. National Museum (No. 62.2559).*

COMPANY PAINTING

'Company Painting' designates the style of Indian painting, patronized by the Europeans, chiefly by the officers of the British East India Company in the 18th and 19th century. In the early 19th century, it came to be known as the 'Patna School.' But this term failed to project the pan-Indian character of this vivaciously hybrid pictorial idiom. The gradual breaking up of Mughal suzerainty, in part, led to the British East India Company playing a greater political and administrative role in India. The country became a jewel in the crown of the British empire. It attracted lawyers and surgeons, intellectuals and artists, besides merchants and adventurers. These English residents and travellers made a fruitful discovery of native artists 'who were as talented and obliging as they were plentiful.'

Artists once active in the Mughal workshop, or under the patronage of some feudal aristocracy in eastern and northern India were out to seek other lucrative employment. They migrated to the newest centres of power adapting themselves quickly to the changing patterns of patronage.

Many of the British officers were amateur watercolourists or able draughtsmen. On survey trips they engaged native painters and helped them to introduce stylistic changes, in keeping with their penchant for true-to-life naturalism. B.H. Baden Powell was one such civil servant and a promoter of Indian handicrafts. While assessing the skills of a miniature painter (of Punjab) he lamented on the absence of elementary principles in his creations which were familiar to even an average Englishman:

His colour is often exaggerated but it is always warm and rich and fearless. The native artist is also patient: for weeks and months he will work at his design, painfully

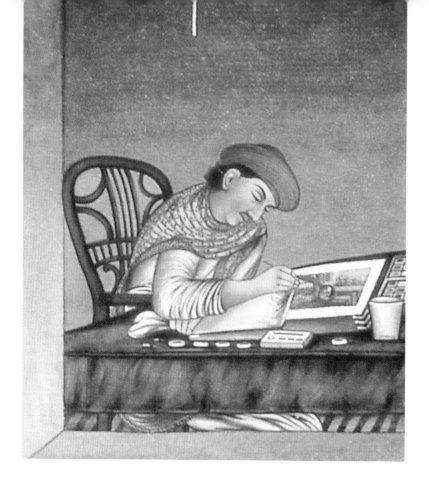

Indian artist, in her employ to copy some of her lively sketches. Similarly, Colonel Jean Baptiste Joseph Gentil while in Faizabad, employed Nevasi Lal, a local painter, to make a miniature version of Tilly Kettle's large oil portrait of the Navab Shuja ud-Daula (1754-75). Such first-hand exposure to European painting had a decisive impact on the working methods of native painters of the Company era. Painters moulded their pictorial concepts afresh by studying and copying the European models available. The challenges of the new requirements were often met with a zeal to revamp the traditional technique of brilliantly hued opaque watercolour. The practice of pencil drawing with sepia-wash shadows and fine cross-hatchings gained much ground. The concept of perspective was often experimented after the European prints. The direct study of nature was favoured instead of relying on memory. Thin washes of watercolour on mill-made paper from England, with areas finished in gouache, yielded an altogether different effect. The painters imitated the immaculate blending of soft tonalities as done in oil technique and added functional volume to human figures, drapery and architectural details with calculated distribution of directional light and cast shadow. Newer media, namely glass, mica, ivory and shell also became popular among the visiting European collectors.

elaborating the most minute details; no time is considered too long, no labour too intense to secure perfection in imitation or delicacy in execution. The greatest failing in native artists is their ignorance of perspective and drawing, and it is fortunate that this want is most easy to supply.

(*Handbook of the Manufactures and Arts of the Punjab*, 1872, p. 355)

Native talents were also employed by professional and amateur artists visiting India. Emily Eden, sister of the Governor General, Lord Auckland, had Azim, an

The wide range of subjects painted were determined by the new clientele's deep-seated appetite for Indian picturesque. 'We have here,' vividly narrated Captain G.C. Mundy in 1832, 'domes, minarets, fanciful architecture and costume above all flaunting in colour, set off with weapons and formed, from the easy flow of its drapery, to adorn beauty and disguise deformity... Every hut, equipage, utensil and beast of India is picturesque.' Of popular appeal were the sets illustrating customs, occupations (firkas) and prevalent crafts, methods of transport, festivals and the historic Mughal monuments of Delhi and Agra. Depictions of Hindu deities and mendicants in varying sectarian attire represented Indian rituals and religious life.

The earliest surviving examples of Company Paintings were produced in south India at Madras, Tanjore and Trichnopoly during the second half of the 18th century. With increasing British influence, the bright coloured backgrounds of Golconda ancestry were softened and the iconic stance of the human figures were curbed in favour of naturalistic standards. Paintings for the British stationed in eastern India were later produced at Murshidabad, followed by impressive developments at Calcutta and Patna, Banaras and Avadh. Shedding the intricacies of the late Mughal style, the Murshidabad Company idiom crystallized by 1780s. An illusionistic approach was George Farington's gift to the local painters who deftly combined mellow sepia tones and elongated figural structure into their technique.

Kayastha painters migrating from Murshidabad as early as c. 1790 found a new market among the British settled in Patna. Among them, Sevak Ram (c. 1770-1830) painted vast panoramas in transparent tints while Hulas Lal (c. 1785-1875) specialized in ambitious pictures of festivals. The civil servant and baronet Sir Charles D'Oyly was a prolific artist who trained Jai Ram Das and Shiv Dayal, 'the first Indians to produce pictorial lithographs.' By the mid-19th century the Patna style lost its precision.

In Avadh, the Navabs themselves were the patrons of European art and had a number of British painters at their courts. Conventional sets, depicting aspects of Indian life became popular towards the beginning of the 19th century. Female performers or 'the ladies of the night' formed an attractive genre.

The brief late-Mughal impact and the localized version of the Jaipuri idiom, however, had little to do with the style of Banaras Company Painting. Patna painters migrated to the city as early as c. 1815. Possibly for this reason, a European-influenced Patna idiom was developed with little modification in the early 19th century. The technique of painting on mica, ivory and glass was also perfected.

Facing Page

Artist seated at a table painting a picture. Avadh, watercolour on paper (1815 watermark), 23.5 x 19.6 cms. c. 1815-20. British Library. (Add. Or. 347).

137

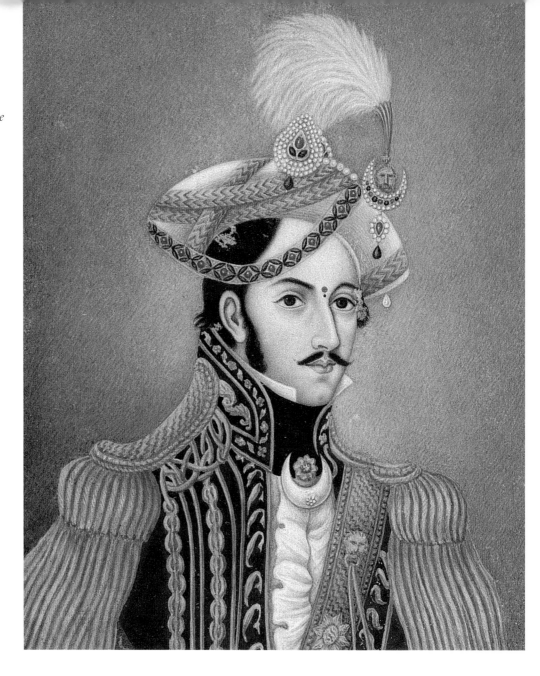

Col. Matvar Singh. Banaras, c. 1840, opaque watercolour on ivory; 10.7 x 8.5 cms. Bharat Kala Bhavan (No. 305).

When the British occupied Delhi in 1803 there were still many families of skilled painters. They were employed to prepare architectural drawings of the monuments in Agra, Sikri and Delhi. Sets of highly finished portraits of the Mughal emperors were painted on ivory. Pictures of dancing girls and accompanists were considered ideal gifts to be presented to invited guests for a *nautch* evening.

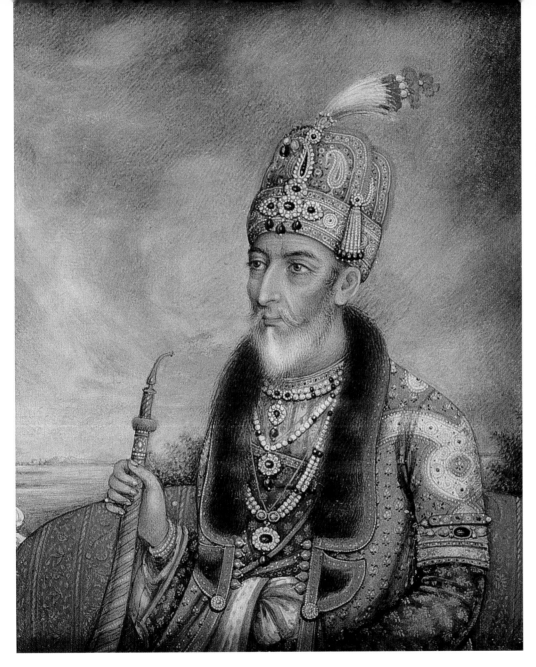

Bahadur Shah II. Delhi, c. 1850, opaque watercolour on ivory; 12.5 x 10 cms. Victoria and Albert Museum (No. 03575:IS).

E.B. Havell (1861-1934) made pioneering efforts towards a nationalist revival of Indian art in the early 20th century. He appointed the last of the major Company painters from Patna, Lala Isvari Prasad (1870-1950) at the Government School of Art (founded 1854), Calcutta, to teach the intricacies of miniature painting and aspects of ornamental art.

Worshippers sacrificing goats before an image of Kali trampling on Shiva. Patna, c. 1858, opaque watercolour on mica (talc); 20 x 13.6 cms. National Museum (No. 49.10:25). The Company painters who were quick to adopt the technique of transparent watercolour painting on the firm support of machine made paper found other materials namely, glass, mica, ivory and shell equally feasible. Popularization of the glass painting may be traced back to the Chinese examples serving as the principal inspiration to the Indian painters in the late 18th century. Painting on mica (talc), another novelty attracting the British in India, was practised chiefly at Murshidabad, Patna, Banaras and Trichonopoly. On mica, as on glass, the painting was done from the reverse. The outlines and the stippling were done at first and subsequently body colours were applied to different parts of the painting. Inspite of the fact that the ancient Indians knew the art of ivory carving, portraits, icons and scenes from daily life were fashioned on small ivory panels only in the 18th century and much under the direct influence of British miniaturists namely, Ozias Humphrey (1785-87), John Smart (1785-95), George Chinnery (1802-25) and many others, visiting native courts. Carefully stippled and tinted with transparent watercolour the gem-like ivory panels were often mounted on boxes, writing cabinets or were used as buttons and collar studs. By the late 19th century ivory painters catered essentially to the tourists, visiting Delhi and Agra and produced for them head and shoulders portrait series of Mughal emperors as well as views of monuments in Delhi, Agra and Sikri as fanciful bijouterie.

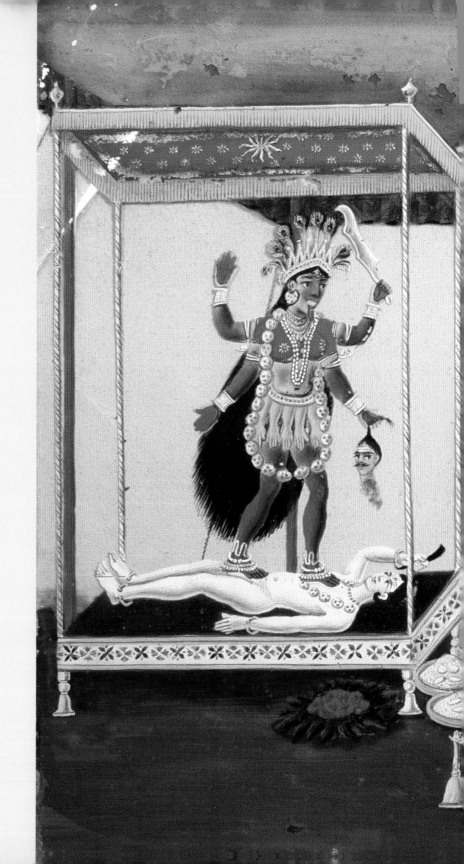

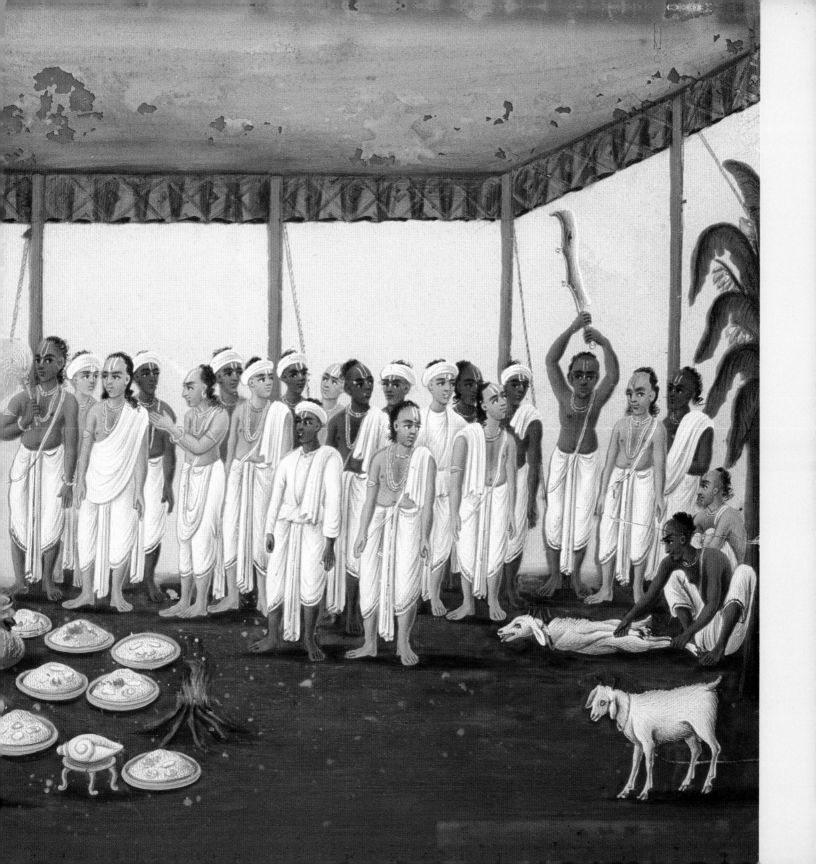

BIBLIOGRAPHY

Abu'l-Fazl Allami. *The Ain-I-Akbari*, translated by H.Blochmann and H.S. Jarrett, 3 vols., Calcutta, 1927.

Abu'l-Fazl Allami. *The Akbarnama*, translated by H. Beveridge, 3 vols., Revised ed., Delhi, 1972.

Adle, Chahryar. 'New Data on the Dawn of Mughal Painting and Calligraphy', Mazaffar Alam et al., (ed.) *The Making of Indo-Persian Culture,* New Delhi, 2000, p. 167-222.

Archer, Mildred. *Company Paintings: Indian Paintings of the British Period,* London, 1991.

Barrett, D. and Gray, B. *Indian Painting,* Geneva, 1963.

Beach, M.C. *The Imperial Image: Paintings for the Mughal Court,* Washington, 1981.

Beach, M.C. *Mughal and Rajput Painting,* Cambridge, 1992.

Beach, M.C. and Koch, Ebba. *The King of the World: The Padshahnama,* Sackler Gallery, 1997.

Bernier, Francois. *Travels in the Mughal Empire: 1656-68,* London, 1934.

Chandra, Moti. *The Technique of Mughal Painting,* Lucknow, 1949.

Chandra, Moti. *Studies in Early Indian Painting,* Bombay, 1970.

Chandra, Pramod. *The Tutinama of the Cleveland Museum of Art,* Graz, 1976.

Coomaraswamy, A.K. *Rajput Painting,* 2 vols., London, 1916.

Crill, Rosemary. *Marvar Painting,* Mumbai, 2000.

Daljeet, Dr. *Mughal and Deccani Paintings,* New Delhi, 1999.

Das, A.K. *Mughal Painting during Jahangir's Time,* Calcutta, 1978.

Das, A.K. (ed.) *Mughal Masters – Further Studies,* Bombay, 1998.

Dickinson, E. and Khandalavala, K.J. *Kishangarh Painting,* New Delhi, 1959.

Digby, Simon. 'The Literary Evidence for Painting in the Delhi Sultanate', *Bulletin of the American Academy of Benares,* 1967, Vol.I, p. 47-58.

Doshi, Saryu. *Masterpieces of Jaina Painting,* Bombay, 1985.

Ebeling, K. *Ragamala Painting,* Switzerland, 1973.

Goswamy, B.N. *Essence of Indian Art,* San Franciso, 1985.

Goswamy, B.N. and Fischer, E. *Pahari Masters,* Zurich, 1992.

Guy, J. *Palm Leaf and Paper: Illustrated Manuscripts of India and Southeast Asia,* Melbourne, 1982.

Guy, J. and Swallow, D. (ed.) *Arts of India: 1550-1900,* London, 1990.

Koch, Ebba. *Mughal Art & Imperial Ideology,* Oxford, 2001.

Krishna, A. *Malva Painting,* Varanasi, 1963

Krishna, A. 'Migration of Delhi Style to the Maratha Kingdom', *Marg,* Vol. XXXIV, No. 2, p. 96.

Leach, Linda York. *Mughal and other Indian Paintings from the Chester Beatty Library,* 2 vols., London, 1995.

Losty, J.P. *The Art of the Book in India,* London, 1982.

Miller, B.S. T*he Gitagovinda of Jayadeva,* Delhi, 1977.

Okada, Amina. *Imperial Mughal Painters,* Paris, 1992.

Pal, P (ed.) *Master Artists of the Imperial Mughal Court,* Bombay, 1991.

Porter, Yves. *Painters, Paintings and Books*, Delhi, 1994.

Randhawa, M.S. *Basohli Painting,* New Delhi, 1959.

Sen, Geeti. *Paintings from the Akbarnama*, New Delhi, 1984.

Seyller, John. *The Adventures of Hamza*, London, 2002.

Thackston, W.M. *The Baburnama: Memoirs of Babur, Prince and Emperor,* Oxford, 1996.

Thackston, W.M. *The Jahangirnama: Memoirs of Jahangir, Emperor of India,* Oxford, 1999.

Topsfield, A. *Paintings from Rajasthan,* Melbourne, 1980.

Topsfield, A. (ed.) *Court Painting in Rajasthan,* Bombay, 2000.

Wade, Bonnie C. *Imaging Sound,* Chicago, 1998.

Welch, Stuart Cary. (ed.) *Gods, Kings, and Tigers: The Art of Kotah,* New York, 1997.

Welch, Stuart Cary. *Imperial Mughal Painting,* New York, 1978.

Welch, Stuart Cary. *India: Art and Culture,* New York, 1985.

Zebrowski, M. *Deccani Painting,* London, 1983.

ISBN: 81-7436-334-3

© **Roli & Janssen BV 1996**
This edition published in 2005
in arrangement with Roli & Janssen BV, The Netherlands
M-75 Greater Kailash II (Market) New Delhi 110 048, India
Ph: ++91-11-29212782, 29210886; Fax: ++91-11-29217185
E-mail: roli@vsnl.com; Website: rolibooks.com

Editor: Nandita Jaishankar; *Design:* Arati Subramanyam
Layout: Kumar Raman, Naresh Mandal; *Production:* Naresh Nigam

Printed and bound in Singapore